Art with an iPhone
Photo Techniques & Apps

Beth Alesse ▪ artist, writer & educator

Beth Alesse is an author, photographer, graphic and digital artist, and editor. In addition to writing, she curates image collections to present in books and media productions. She holds degrees in art and education, and has a broad background in graphic arts, linguistics, and visual and digital media.

Her books with Amherst Media include *Phone Photography for Everybody: Still Life Techniques, The Moon, The Earth: A Visual Story of Our Amazing Planet, The Sun: NASA Images from Space and Hubble in Space: NASA Images of Planets, Stars, Galaxies, Nebulae, Black Holes, Dark Matter, & More.*

Published by:
Amherst Media, Inc.
P.O. Box 538
Buffalo, N.Y. 14213
www.AmherstMedia.com

Publisher: Craig Alesse
Publisher: Katie Kiss
Senior Editor/Production Manager: Barbara A. Lynch-Johnt
Senior Contributing Editor: Michelle Perkins
Editor: Beth Alesse
Acquisitions Editor: Harvey Goldstein
Editorial Assistance from: Carey A. Miller, Roy Bakos, Jen Sexton-Riley, Rebecca Rudell
Business Manager: Sarah Loder
Marketing Associate: Tanya Flickinger

ISBN-13: 978-1-68203-465-1
Library of Congress Control Number: 2021932879
Printed in The United States of America.
10 9 8 7 6 5 4 3 2 1

www.facebook.com/AmherstMediaInc
www.youtube.com/AmherstMedia
www.twitter.com/AmherstMedia

Contents

Introduction
Art with an iPhone
Photo Techniques & Apps

*Our cameras are always with us, and we are
ready and able to take photos anytime.*

This book, *Art with an iPhone: Photo Techniques & Apps,* is about using creative methods in iPhone photography to make art. It covers a wide range of approaches and techniques, from reviewing overlooked tools in your wheelhouse, to discovering new tools and skills, to new approaches to breaking into a new mindset, to exploring transformative apps. Creativity often brings us to the edges of our comfort zone, and that's where we can explore, discover, and the make novel, imaginative artful image.

The iPhone camera is the ideal instrument to push our boundaries and create amazing images. Our cameras are always with us, so we are ready and able to create anytime. We do this because it is part of human nature. We must capture, create, envision, and produce art.

Many of the creative techniques need only the iPhone camera. Some techniques use third-party apps. Often creative skills lie with the human who holds the camera, their perspective, and intent.

Creating art in iPhone photography is limitless no matter the apps you use. Creativity is the invention of something original, unique, or innovative. Art-making techniques are a collection of skills and tools used to execute a task, to carry out a creative procedure. This book looks at approaches to doing artistic works and explores many app techniques to make art—skillful, imaginative images. Create something a little different or like one of the great art masterworks. There is something to pique everybody's interest.

BethAlesse@AmherstMedia.com

1 iPhone Camera Apps and Shooting Techniques

The Native iPhone Camera App

Native apps are the apps that come with iPhones and iPads. These do not have to be purchased, and they are frequently updated. I use the iPhone 12 Pro Max, my newest phone at this time. This iPhone and most newer iPhones have three camera choices (not including the video): PHOTO, PORTRAIT, and PANO. This chapter touches on each. You can also choose from two or three lenses when PHOTO or PANO is selected, depending on which iPhone model you are using. The lenses on the Pro Max are a 0.5 (a wide-angle lens), 1x (a conventional lens), and 2.5 (a telephoto lens). Other selections are LIVE, TIMERS, FORMAT, EXPOSURE adjustment, FLASH, HDR, and a set of presets. The iPhone 12 Pro Max also has a nighttime mode.

These selections give the camera a substantial amount of functionality.

The flash, format, and timer are straightforward. Explore the screen, and you'll learn to navigate around these selections. LIVE, if you haven't used it before, can be toggled on and off. Using it lets you capture several frames at once. When editing, you can choose a different key photo than the one automatically chosen as the prime image in thumbnails, for printing, or to import into other apps. LIVE is helpful to get the precise moment in a succession of moments. Avoid closed eyes in portraits, and capture the most exciting part of a skateboard jump. I rarely use the preset selections when shooting, as they are also a choice when editing.

Camera apps can be purchased, too. The Moment lenses app is free and is useful to use even without using their lenses. Other apps are Camera+2, ProCamera, and Slow Shutter, among many others.

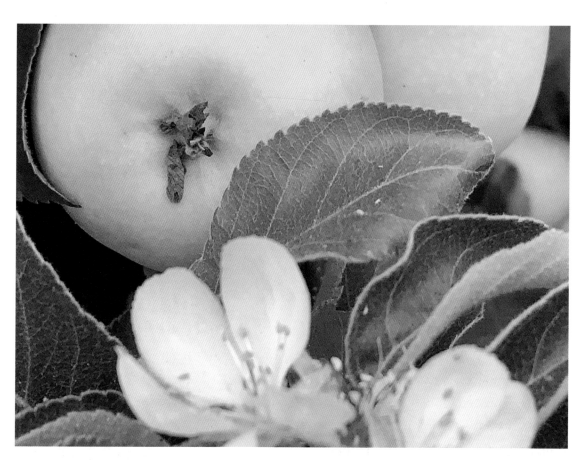
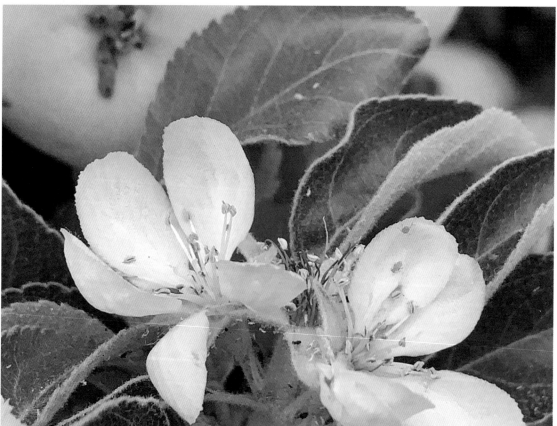

Focusing Techniques

Focusing on the iPhone is easy. Most of the time, the autofocus feature does all the work for you, and it does a good job. However, if you want a specific part of the subject in focus, touch the part of the image that you want to be sharp. In these two images of an apple's fruit and blossom, I took two exposures. For one photo, I touched the fruit and the other the flowers. The distance between the two objects was only a few inches. When a particular subject is critical in your photo, make sure to tap it on the screen. A yellow square appears on the screen to let you know which area is in focus.

A longer touch achieves a focus and exposure lock. The screen shows if the focus is locked. Adjust the exposure by moving your touch either up or down on the right of the yellow box. The sharpness retains during the exposure adjustment. It's important not to change the distance between the object of the focus lock and the iPhone. It is the distance and not the actual object that determines the link. Releasing the lock is as simple as touching another area on the screen.

Focus lock comes in especially handy if there is movement in the background behind your subject. This movement can trigger the iPhone's autofocus if the lock is not engaged. A street with driving cars was behind the skateboarder. He always did the jump on the same step. I locked the focus at this distance, waiting for him to be airborne without worrying about the camera refocusing on background motions.

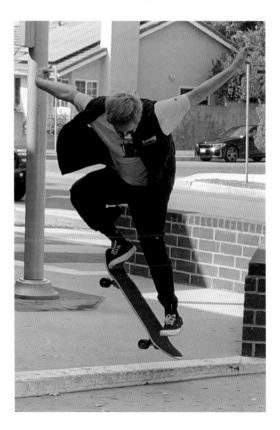

Panoramas

Panorama is one of the basic options on the iPhone camera. As the camera moves in the direction indicated by the arrow, separate exposures stitch together. It helps to keep the camera steady. Keep your feet planted. Hold the iPhone firmly. Pivot by moving either from left to right or from right to left. Touch the opposite side of the screen to change the starting point. Panorama photos take some practice. The smoother your motion, the more seamless the stitching is. Locking your elbows against your body helps.

Putting your iPhone on a tripod works too. Adjust the tripod so that as you swivel the camera, the motion is parallel to the ground.

Panoramas are a fun way to document an environment. Some landscapes will stitch better than others. The characteristic distortions of iPhone panoramas will become evident. You can work to eliminate them or consider the distortion part of the panorama's appeal. After you get the hang of panorama shots, try a vertical panoramic photo.

Slow Shutter
Motion Blur

This image, *Dynamic Dog Walking*, was taken using an app called Slow Shutter, a downloaded app.

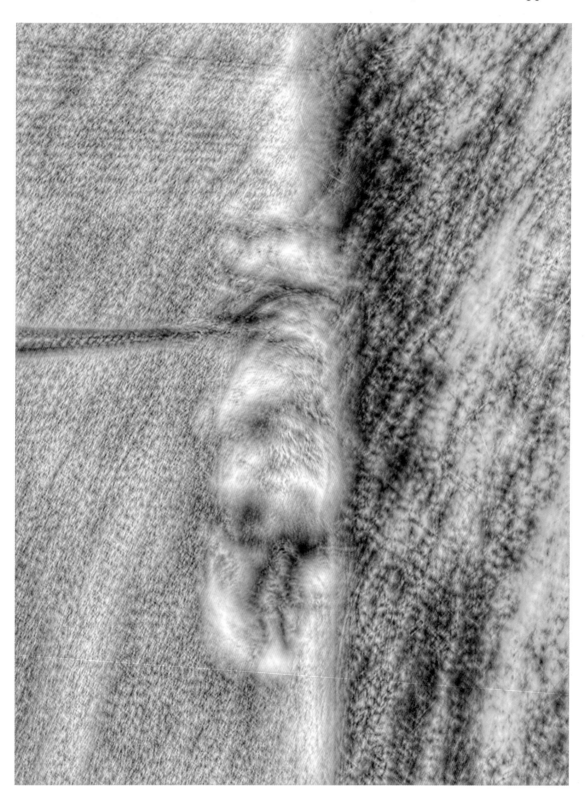

I've always enjoyed the painting by Giacomo Balla called *Dynamism of Dog on a Leash*.at the Albright-Knox Art Museum. It shows the multiple positions of the human and dog's feet (and tail) as they walk. The motion that I captured is different than Balla's because of the angle. I boosted the contrast and the color saturation using Snapseed in the final image *(facing page)*. It is a difficult task to decide which one is the final image. Some may prefer the more subtle original *(below)*.

The line between the grass and the sidewalk is off-center and slightly to the right. The balance is maintained because the dog is nearly on the vertical center. Also, the leash appears to pull to the left, further contributing to this balance.

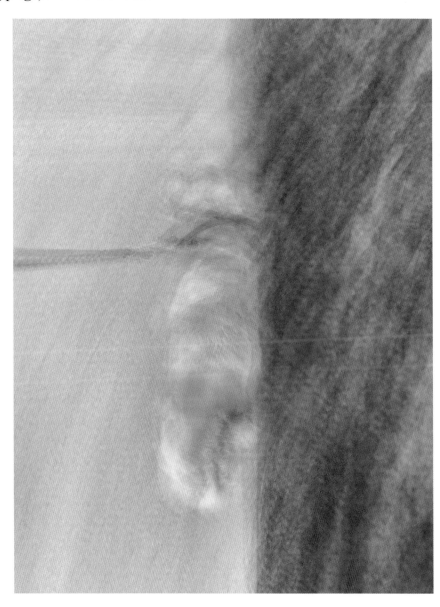

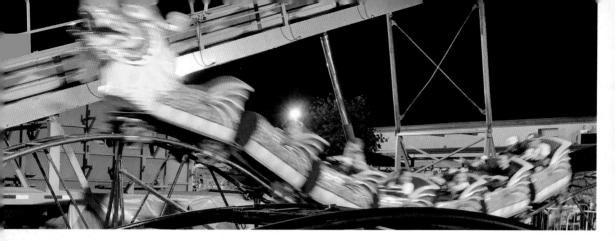

Create Excitement with Motion Blur

Motion blur creates a feeling of motion and speed, and it has been used extensively by artists since the invention of photography. This artistic technique is counter to phone cameras' essential apps because of their design to reduce blur from camera shake or object motion. Most of the time, reduced blur is what we all want. A camera app, such as Camera+2, which has manual control of the shutter speed, is needed to create blur. One dedicated motion blur app is Slow Shutter, and I used it for these images. Capture modes, Motion Blur, Light Trail, and Low Light open the door to creativity. In the Motion Blur mode, settings are for blur strength, shutter speed, and ISO.

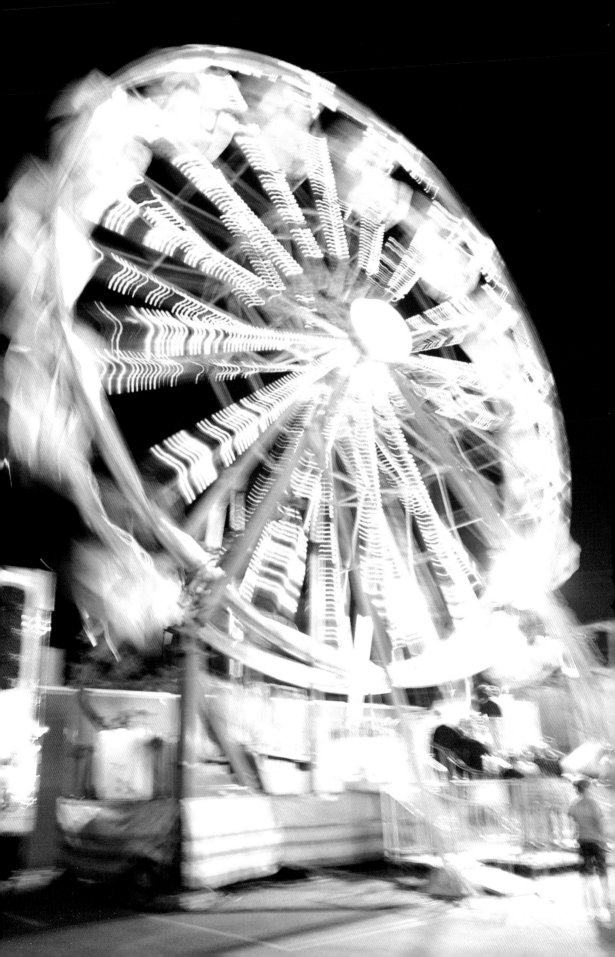

Portrait Mode

Portrait mode is an option in the iPhone's native camera app that can make images with a singular subject stand out. Portrait mode can be used for objects as well as people. It offers five different settings: natural light *(top),* contour light *(upper middle),* stage light *(lower middle),* stage light mono *(bottom),* and high-key light mono *(facing page).* One of these five settings is selected at the time of exposure. The selection can be changed to one of the other four Portrait settings when editing the photo. The subject needs to be within a designated range from the camera lens. The screen tells you if you need to be closer or farther away. Experimentation with portrait mode settings will give you a feel for what works and what doesn't work under different lighting conditions.

The iPhone 12 series is equipped with LIDAR. It is an acronym for Light Detection and Ranging. It improves the iPhone camera's focus, especially when using portrait mode in low-light conditions. It works by pinging the objects in front of the camera to sense their distance.

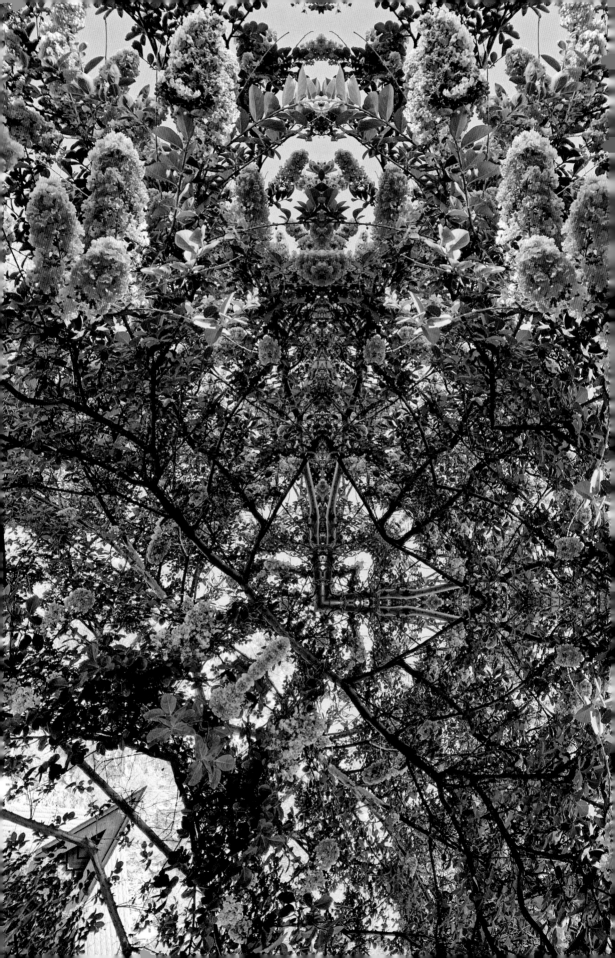

Kaleidoscopic Capture

Nception is an app that has numerous kaleidoscopic-like mirroring possibilities. The app can capture images. Nception can also process previously taken photos. The symmetry created in each image is mesmerizing. Each of the lens choices shows a grid indicating the particular pattern. For example, the smaller image *(below)* has two lines of symmetry, one vertical and one horizontal. The larger image *(facing page)* has

the same lines of symmetry, with an additional diagonal-line of symmetry in the lower left quadrant. The structures can be exceptionally intricate. They can appear simultaneously abstract and realistic, organized and

"The symmetry created in each image is mesmerizing."

caotic, and simple and complicated. The patterns created are intriguing.

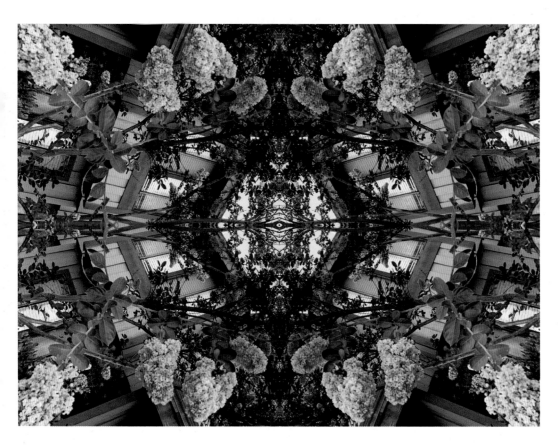

Try Different Lenses

Many phones have more than one lens. The iPhone 12 Pro and Pro Max have three lenses that face forward. Don't forget about trying each of them. No matter how many lenses your phone has, attaching an external lens to one of them makes the image look very distinct. Each attachable lens (fisheye, telephoto, macro, or wide-angle) makes a very different image of your subject.

I used a Moment macro lens for this photograph of a snail. The lens put the background and foreground out of focus, but the snail is sharp.

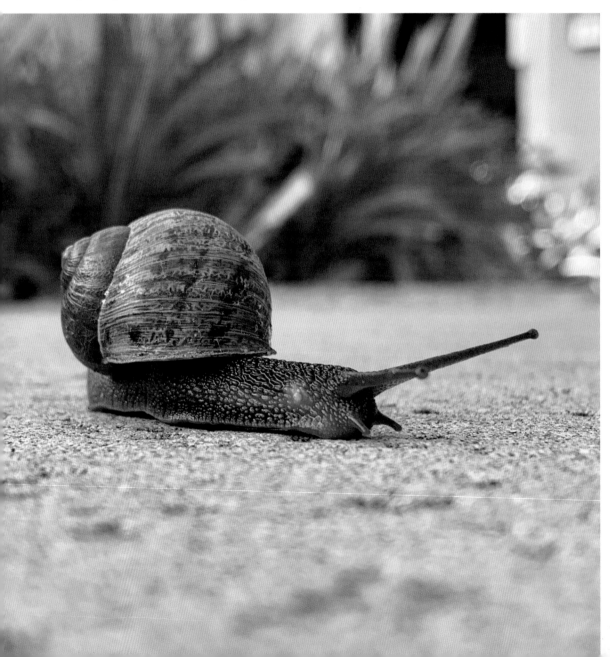

A Dog's View with a Fisheye Lens

The image began as a photo taken as I was waiting to board a flight with my canine companion. He was sitting safely near my feet, watching the stream of people go past. I attached my Moment fisheye lens, lowered my camera to my dog's level, and took a couple of shots. A fisheye lens usually bends the horizon. The distortion of the horizon line is seen in this image as it bows upward in the middle. Depending on the angle, the horizon placement, it is pulled upward or downward. The fisheye lens is an ultra-wide-angle lens that can create hemispherical images. There are many such lenses made for phone cameras.

In a genuine dog's view, the dog wouldn't be included. But I thought its inclusion gave a better visual narrative. Getting down to another level to take a shot is not something we always feel comfortable doing. A selfie stick or small tripod might help for low camera placement.

The final depiction was made in Adobe's PaintCan app to give it a painterly feel.

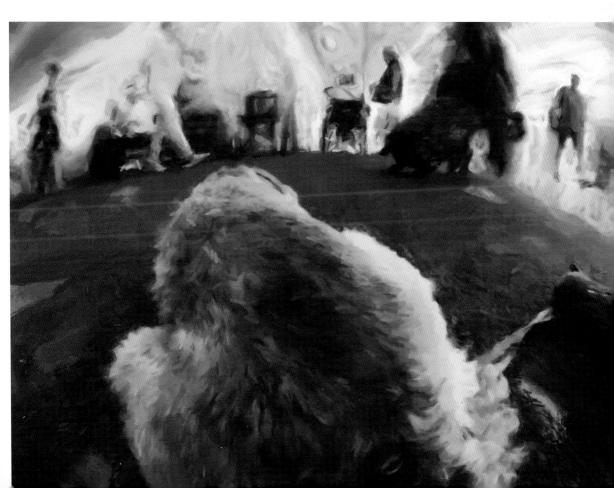

2 Techniques for an Artful Eye

Artful expression through creative techniques, with methods, perspectives, iPhone apps, and more.

Artful expression is biased toward a prepared individual, and preparing is something we can do even before we pick up our iPhone cameras. Your questions may be: How can I be more creative? Is there a secret skill to make art? Or, are there special techniques or skills to make images creatively? A practical beginning is to start with some basic methods for successful compositions. This chapter explains a handful of initial ways to develop an expressive eye. These methods will still be useful later when working at a more advanced level, too. All you need is your iPhone camera, its native apps—the ones that come with the phone, and a few third-party apps.

The techniques covered in this chapter are only a small sample of ideas that can guide your artistic work. These techniques illustrate that what one brings to the iPhone camera can be as important as the camera and apps. By this, I mean your sense of composition, your means of directing the viewer's eye, your chosen style, and your choice of a subject matter.

The iPhone and apps can suggest which elements of composition to employ. Use these suggestions as a springboard to learn about compositional and graphic elements such as line, space, texture, shape, and so on. The apps can supply preset styles without you having to give them a second thought, such as this daffodil flower piece *(facing page)*. However, you can usually refine these styles presented in in-app presets to make them a personal style. The examples in this chapter illustrate creative techniques used with an app to create art.

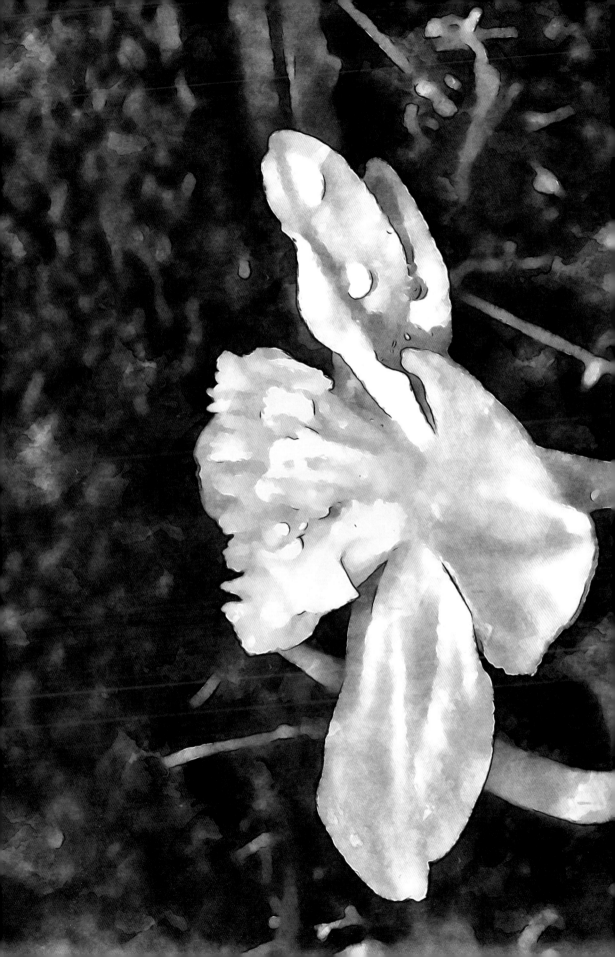

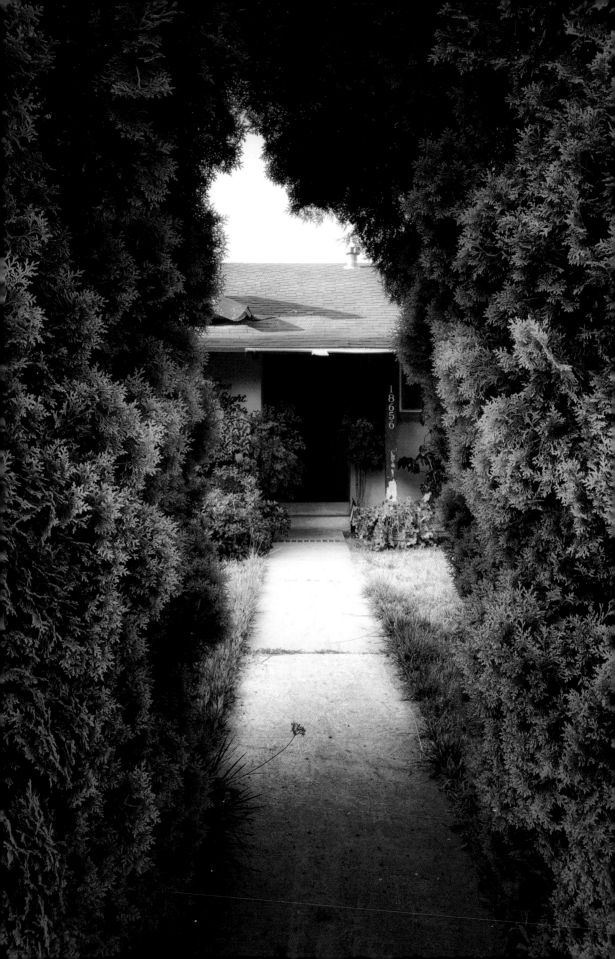

Frame Your Shot

Framing your subject is a creative technique, achieved as the image is captured or later when editing. Framing can help direct the viewer's eye. When taking photos, look around to see if you can shift either your phone camera or the subject so that it is surrounded by foliage, buildings, shadows, or whatever you can find to create a periphery around your subject. It doesn't need to be completely encompassing, just enough to tell us what is the focal point of the image.

Framing can establish a mood or state of mind. It can transform a subject by giving more consideration in the viewer's evaluation. An object—which may be very ordinary—if framed in a particular way, can grow in intrigue, esteem, or suspicion.

This image *(facing page)* is of a small suburban house that had tall bushes, growing into each other at about six-feet high, marking the entrance from the sidewalk. It is typical for people to indicate the entryway onto their property, but this instance was a defined demarcation—like a passageway from our world to a fabled Hobbit's burrow.

Starting with the initial photo *(below),* I imported it into the Snap-Seed app. I selected a preset as a starting point. Then I increased the saturation. This effect made the house more inviting. It also made the purple flower leaning over the sidewalk more visible, creating a bit of whimsy. Adding a vignette darkened the vegetation, which increased the frames affect—directing the viewer's eye through the bushes, past the flower, up the walkway, and to the door.

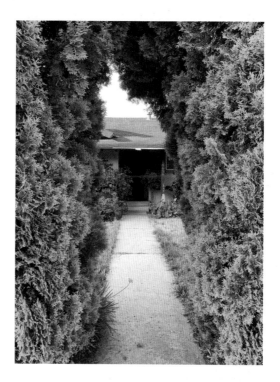

Shoot for the Abstract

Although works may be representational, pieces with compelling compositional elements are more successful. The underlying design elements are evident in all genres, whether the images are realistic, abstract, surrealistic, graphic, or any other style. In abstract works, these elements and principles are more than subtle overtones; the images revolve around these compositional features. These qualities are no longer subordinate to identifiable subjects but become the subjects themselves. Now, these elements and

"Abstract images can feel like puzzles— sometimes playful, sometimes frustrating."

principles are the focus of the created image: design elements—such as shapes, lines, points, planes, and texture—and design principles— such as rhythm, repetition, emphasis, balance and alignment, contrast, proportion, movement, and white space. Even if working with abstractions isn't your preference, doing so for a time can make your subsequent realistic work more mature and impactful.

Many apps create varying degrees of abstraction of an image. The Nception app is used for photo and video, creates a fractured image at the time taken. The fractioning effect depends on movement, and this motion is either what is moving in the camera's view or the camera's motion. Previously taken photos cannot be imported as in many other apps.

I took this photo using the Nception app in a restaurant reception area, peopled with moving limbs. On close inspection, one can see faces, feet, tiled floors, lighting, and other patterns. In terms of design elements and principles, the overall shape is a square. Repeated squares make a pattern that seems to twist and turn. Each square contains an object of the total subject. Abstract images can feel like puzzles—sometimes frustrating, sometimes playful.

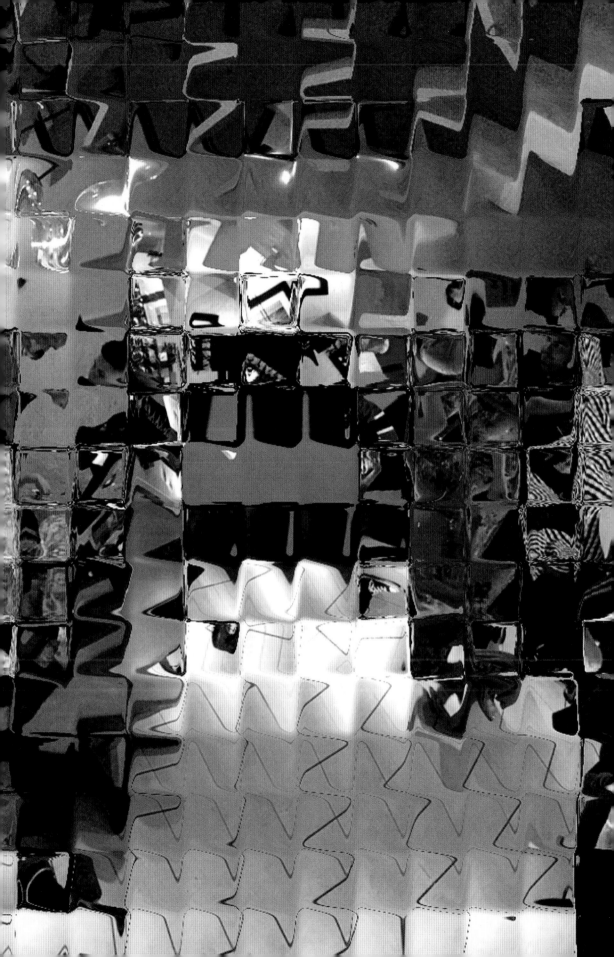

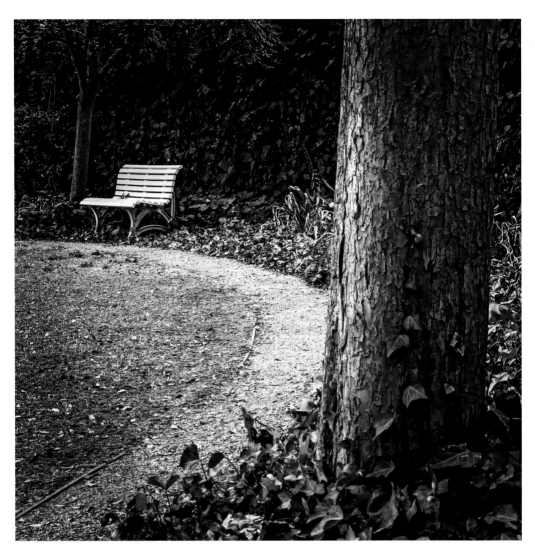

Rule of Thirds

Rule of thirds is a simple way to compose your images. But it can help you transform your photos into artful imges. Most camera apps have a grid that can be toggled on and off that divides the viewed image as thirds, vertically and horizontally. It looks like a tic-tac-toe grid, with two lines horizontally and two vertically. There are four points where the lines intersect. Start by placing elements of a subject at any of the intersections of the lines. Or a place linear element on any of the lines. The placements don't have to be exact, and it's good to keep it simple.

When I work with the rule of

because of the horizon line. Third and last is to use two or three of the intersecting points to put the main subject and subordinate objects.

"Rule of thirds is a simple way to compose your images."

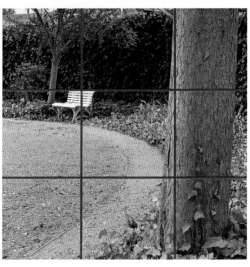

thirds, I like to do it in several ways. First, put the main subject at one of those intersections. Let everything else land as it may, and don't worry about it. Second, put the main subject at one of the intersecting points, and then place either a horizontal or vertical element on one of the thirds lines. It is an easy solution for many landscapes

In this image *(facing page),* the tree trunk aligns in the vertical right thirds line. In composing, I continued using the rule of thirds and placed the bench near the upper left third intersection. The curve exhibited by the landscape boundary creates motion in this otherwise calm image. The curve begins in the lower left, appearing to rebound off the trunk that happens to be at another thirds intersection. Then the curve appears to underline the main subject of the photo—the white bench— before it leaves the photo two-thirds of the way up. I felt the image in black & white was stronger.

I had taken many other photos *(left)* at the same time. However, the rule of thirds didn't apply as successful or well as the final image.

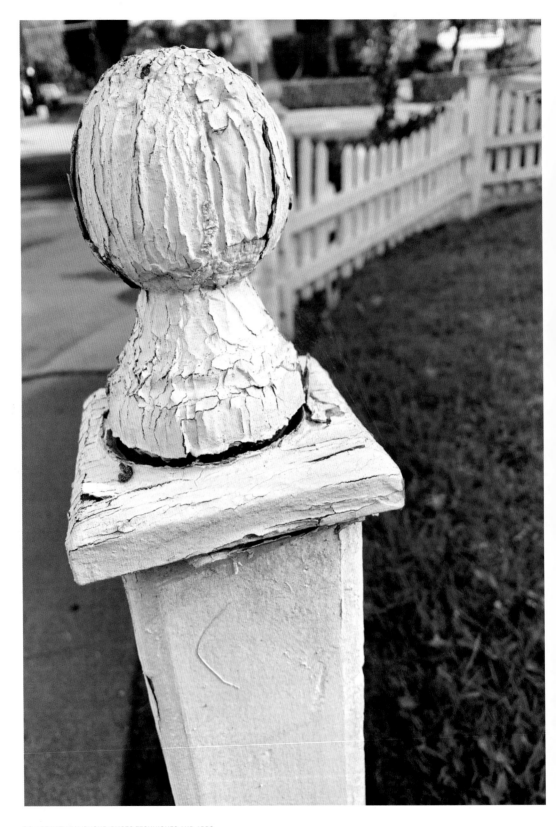

Connect with Curves and Leading Lines

A dependable compositional technique is to include curves and leading lines. They draw the unwitting viewer into and around the image, compelling their eyes to see and explore. Lines and curves let the eyes know where the subject of the photo or picture is located. Because lines and curves encourage us to explore the picture plane, they help us discover the relationship that the subjects have with their environment—its connection with their position or place.

The subject in both of these images is the knobbed cap on the fence post. The knob seems to be anchored—literally and figuratively—by

either the leading line or the curve. The leading line *(below)* recedes backward but leads the viewer's eyes to the spherical cap. The same effect happens on the curved fence *(facing page)*. The subject would not have the same visual weight without the leading line or curve to enhance its place in the composition.

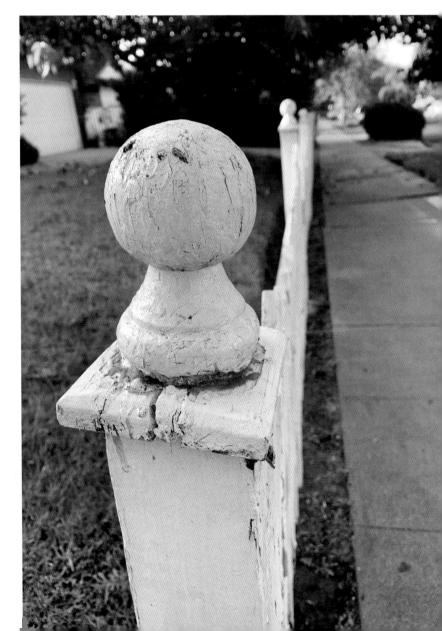

3 iPhone Camera Image Refinement Techniques

The iPhone camera has amazing image-transforming technology contained within it.

Creative art techniques are not only about how you shoot your photos or knowing which apps to use. Often refining an image in the iPhone's primary photo apps can do the trick. We can't forget how powerful, functional, and transformative these essential apps can be in transforming a standard shot into a dazzling one. From the initial start of our new (or refurbished) phone, many of us are unaware of the amazingly image-transforming technology contained within it.

Straighten, Crop, Silhouette, Sepia

This handheld crooked shot *(left)* was squared using the native app

on my iPhone. Making these preliminary corrections can make the outcome of your creative techniques all the more favorable. Some clipping occurs during the straightening process, so always crop after. Since the objects silhouetted against the window, there was no need to make use of the Silhouette preset. I chose instead a sepia preset *(facing page)*.

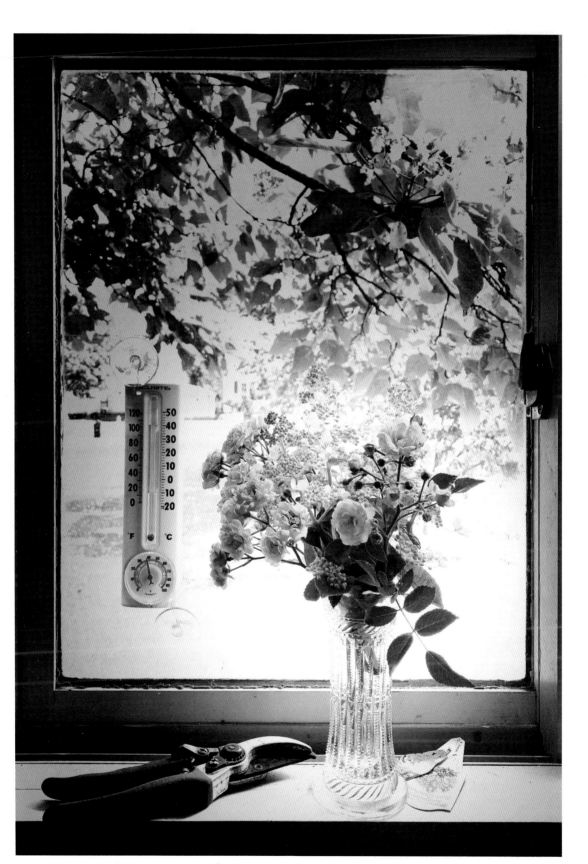

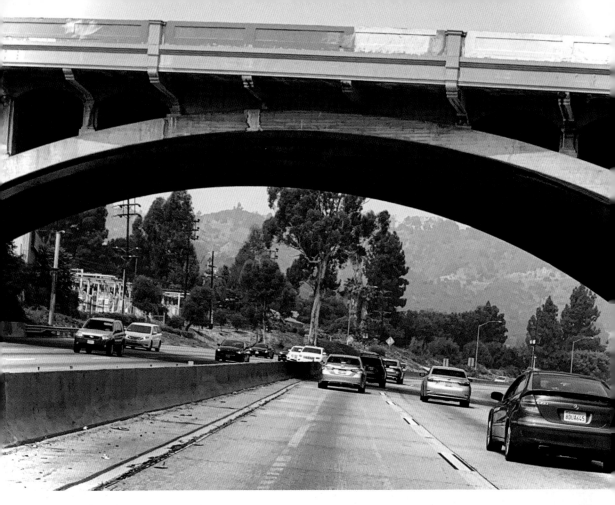

Native iPhone App Refinements

Often the most creative technique you have at the ready is what comes as part of your phone's inherent operating system software and apps. In other words, most phones have essential photo apps with extraordinary refinement capabilities.

After choosing an image in your native Photo app, select to edit it

(see the red ring around Edit on the screenshot, above). The photo will open in the editor.

There are three editing options.

The location of these icons for these choices varies depending on the device and the screen orientation. We see an iPad screen here. The selection is indicated beneath its icon by the presence of a yellow dot. The option shown circled provides ten presets, which can be applied at different percentages.

The circled icon gives you options to crop, rotate, flip, and align. I have created a more dynamic feel to this photo resulting in a keen diagonal element, ideal for portraying the uneasiness of an earthquake-prone landscape. I put the bridge at a more extreme tilt, rather than the more calm horizontal angle in the original image. Also, by cropping the photo, we get a sense of entering under the bridge's arch.

The option circled here gives sixteen different controls of a photo. These are auto, exposure, brilliance, highlights, shadows, contrast, brightness, black point, saturation, vibrance, warmth, tint, sharpness, definition, noise reduction, and vignette.

These white and yellow rings around each of the different controls let you know the degree to which they have been applied. Presets selections will show here, too. Once a preset is chosen, it can be tweaked.

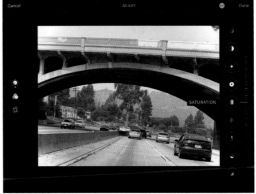

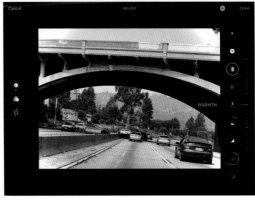

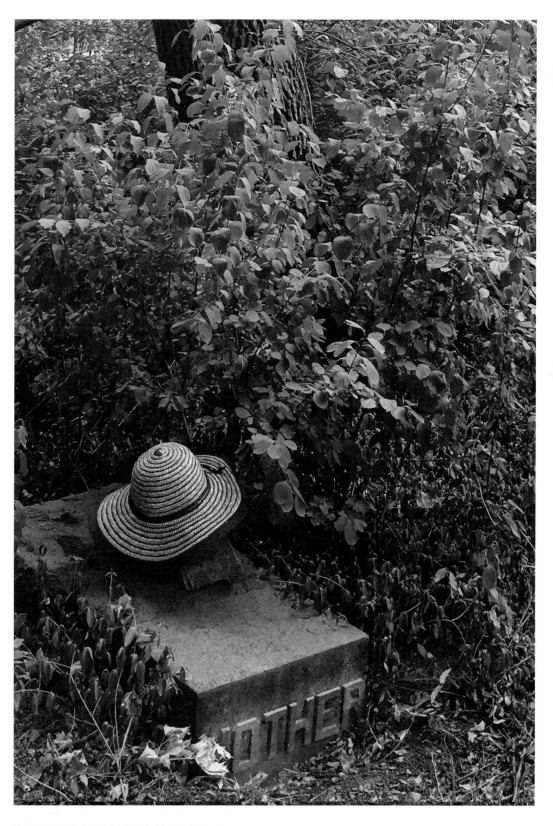

Cropping

Arrange the composition while shooting, but that isn't always possible. So instead, compose and crop when editing. Use the photo app editor. Click on a photo in the photo gallery, and then open Edit. There will be an outer row of three icons, one with a yellow dot that indicates which of the three outer-row icons is selected. The icon for cropping—the one you want—is the same as the one used for straightening an image. This icon looks like a small square with curved arrows at two of the opposite corners. When this is selected, an inner set of icons appears for horizontal and verticle adjustments. Also, on the top left will be adjustments for turning and flipping the image. On the top right is an icon to adjust the image's proportional dimensions. For example, a square format is a choice. However, if you wish to compose your image with the least restrictions, choose Freeform. Freeform lets you pull in the sides of the photo directly on the image sides. You can also pinch, pull, zoom, and maneuver the image into place. When you have it just

right and want to save, select Done, usually located either in the upper or lower right corner. If you want to change the image back to the original, open it in Edit again. If you need to revert to the original photo, select the word Revert, and the original photo is back.

I was walking through a museum grounds and did not expect to find a grave. I took off my straw hat and placed it on top to make the image more personal, warm, and human. The original photo was a more distant shot, and I realized how difficult the word MOTHER was to read. By cropping, the hat and grave become larger and more prominent, a more central subject. The word MOTHER becomes substantial and more legible.

The Power of
Black & White

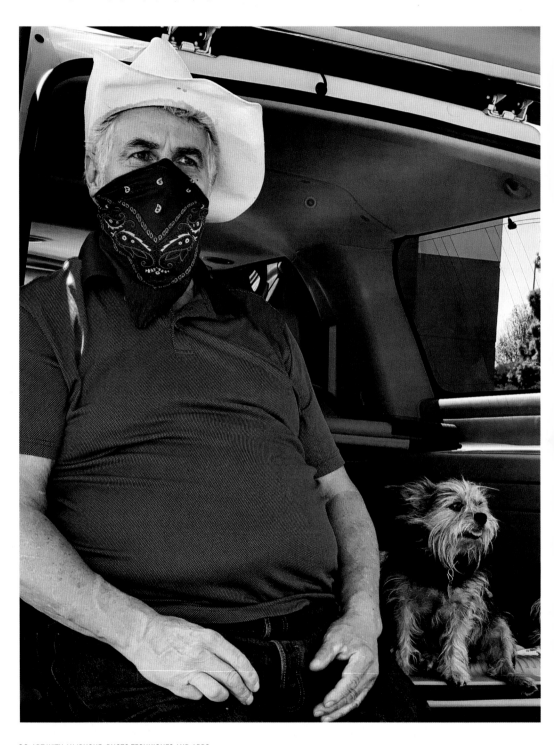

Compare the final black & white image, *Bill and His Rescue (facing page),* with the color original *(bottom left).* The blue clothing and background foliage in the color version detract from the subjects, a man and his dog. By turning the image to black and white, both of the subjects' faces pop into our view, becoming the nucleus. There are no color detractors to pull the viewer away from the lightened faces of man and dog. The encircling middle and dark values meld into a gray mass.

The image was transformed in the Snapseed app using the Noir presets *(top right, middle right).* Try different presets to approximate the look you want. Then, press the Adjust icon for additional refinements *(bottom right).* The menu *(top right)* also gives a set of black & white presets and adjustments. Other apps that offer black & white presets and adjustments are: Afterlight, Noir, Polarr, MOLDIV, XnViewFx, Adobe Lightroom, and Adobe Photoshop Express, among many others.

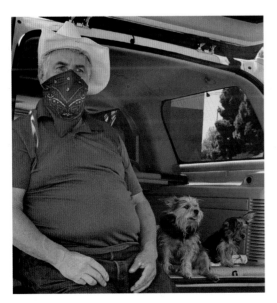

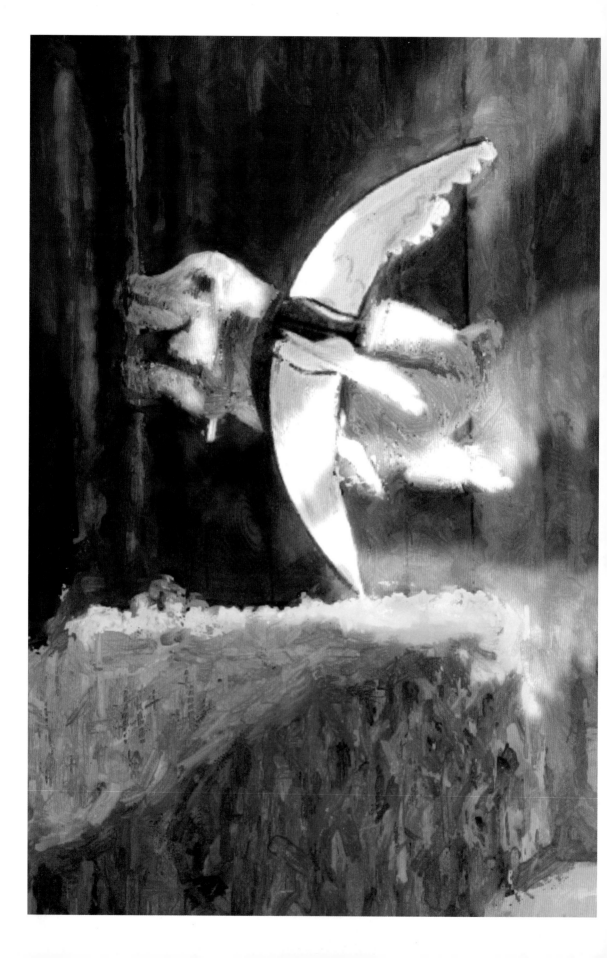

Pig Flies: Technique for Adding Light Beams

I used a photo that I'd taken of a flying-pig kite suspended from a stick in someone's front yard. It stood out nicely against a painted fence. I worked on it in a painting app *(bottom left),* but the pig didn't stand out enough—especially its face. I opened the file in an app called Light. I complimented the light in the photo by choosing a beam and placing it to emphasize the light that had come from the upper right. The added-light effect has these variables: light-source position, brightness, luminescence, range, hue, saturation, displacement, and blur.

The first two Light treated images were not quite what I wanted. One was too dark *(bottom center),* and the other was still not bright enough *(bottom right).* Find the most desirable lighting when shooting the original photo. However, sometimes we need to paint with additional light effects after the fact. The Lighting app, and others like it, offer a great technique for altering or enhancing the light in your images.

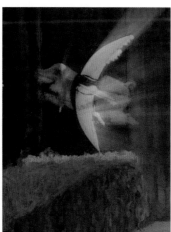

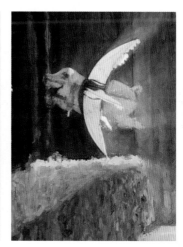

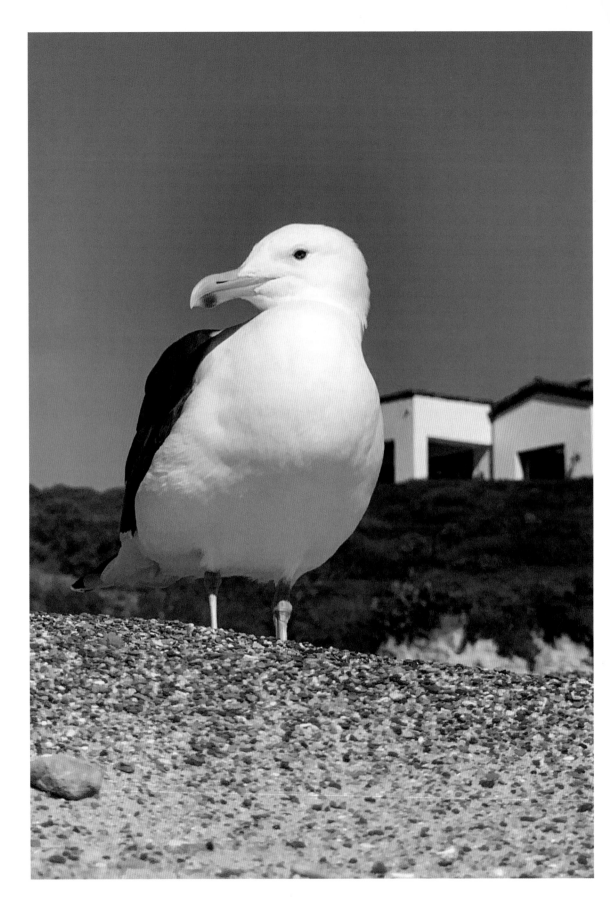

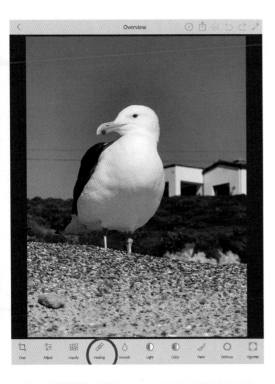

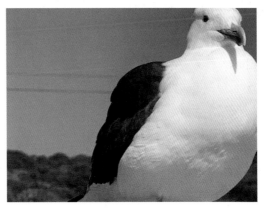

Healing Tool

Healing can transform your photographs. Healing clears up facial blemishes and eliminates stray hairs. It can remove litter and rubbish or even garbage cans, too. In the case of this beach gull, the healing tool removed the distracting wires. Most basic photo editing apps include a healing tool *(see icon circled in red, in the screen shot.)* The healing brush size and edge hardness are adjustable. The reddened selections on the sky show areas which are altered by the healing brush. Do not underestimate the power of an iPhone app's healing tool. This tool is just as or more powerful than computer software doing the same job. The patching and cloning tools give similar functionality.

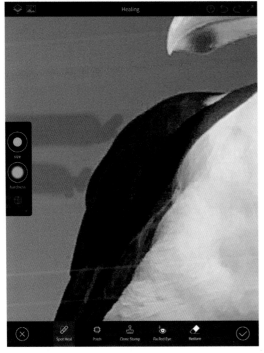

Photoshop Fix Vignette

Vignetting occurs when an image fades around its border. The outer edges can fade to black, white, or any color. It can be a minute change from one tone to another or a change from a focused center to a blurred edge. A vignette helps to focus the viewer's eyes on the subject in the center of the frame. Many editing apps have a vignette tool that allows placement of the vignette center anywhere in the image. Other typical adjustments are the degree of a vignette effect and how gradual the change is from the unaltered image to an affected border. Often, the vignette is so subtle it is barely apparent to the viewer. A vignette serves to direct the viewer to the subject of the image.

Vignetting used on early photography prints such as tintypes, especially for portraiture, is a

traditional technique. So, vignetting can be used to create an old fashioned look or a nostalgic feel to images.

I imported the original image *(top left)* into the Adobe Photoshop Fix app and selected Vignette *(screenshot, middle left)*. The two

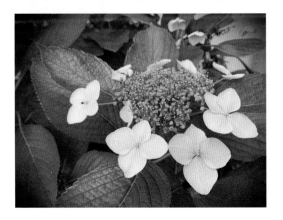

circles control the distance of gradation effect and the elliptic quality of the vignette. I also moved its center somewhat to accommodate the subject. Not all apps have this ability. There is an adjustment for the vignette's color, too. This initial image *(bottom left)* has this effect applied.

Next, I selected the Defocus option *(screenshot, bottom right)*. I used an adjustable brush to paint in a mask, visible as a transparent red in this screenshot. I can be remarkably detailed about the parts of the image I select that are out of focus. The defocused outer edges contributed nicely to the vignette effect in the final image *(facing page)*.

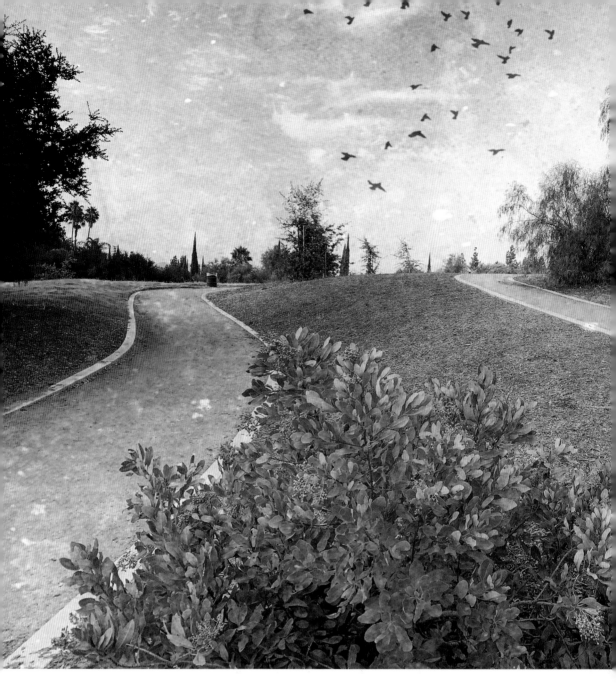

Adding birds and a Horizontal Flip

Something so simple as adding birds to an image can make a somewhat static photo *(facing page, upper right)* enlivened. A simple technique—the addition of an animal—seems to draw the viewer into the landscape. I used the DistressedPX+ app to add

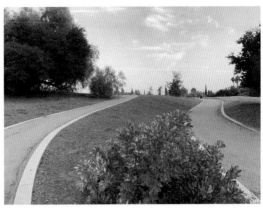

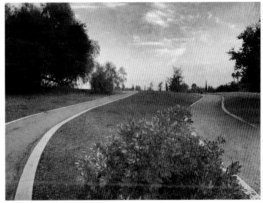

texture and birds *(middle right),* but you can also use any app with a layer's capability to make your additions. The bottom right image is after texture treatment, but before the birds addition and flipping the image horizontally—using the basic phone-camera editing app. Simple adjustments like these advance your efforts into the status of art.

4 Fun and Easy Creative Image Transformations

Easy apps can make your photos look like an artist's creative work.

Transforming your photos into art is very easy to do with the many apps that are available for the iPhone and iPad at the Apple App Store. Although, not the focus of this book, Android phone users can get many of the same apps at sites such as Google App Store. These apps are often inexpensive or even free. Many of the free apps have outstanding functionality but have a pro version for increased editing power. There is a trend of offering a subscription for some apps' higher power levels. Usually, there is a free trial period, so you can decide if this is an app you would use. I have found that the free versions have lots of utility.

Drawings

Traditionally, a drawing is a picture made with a pencil, pen, crayon, or other such implements and is often monochromatic. Drawing apps use your photographs to emulate a drawing version. There are often choices to be made. Background paper gives the impression of an overall texture, such as smooth or rough, consistent or imperfect, straight or wrinkled, and clean or stained. Another choice might is the media simulated in the app, such as soft pencil, hard pencil, ink, charcoal, or crayon. The stylistic choice may be given, such as sketchy, impressionistic, or illustrative.

I imported a photo of a day lily into the My Sketch app. The background paper choice makes it look antique. And the soft, diagonal pencil lines add a character that screams, "Yes, I am a drawing!"

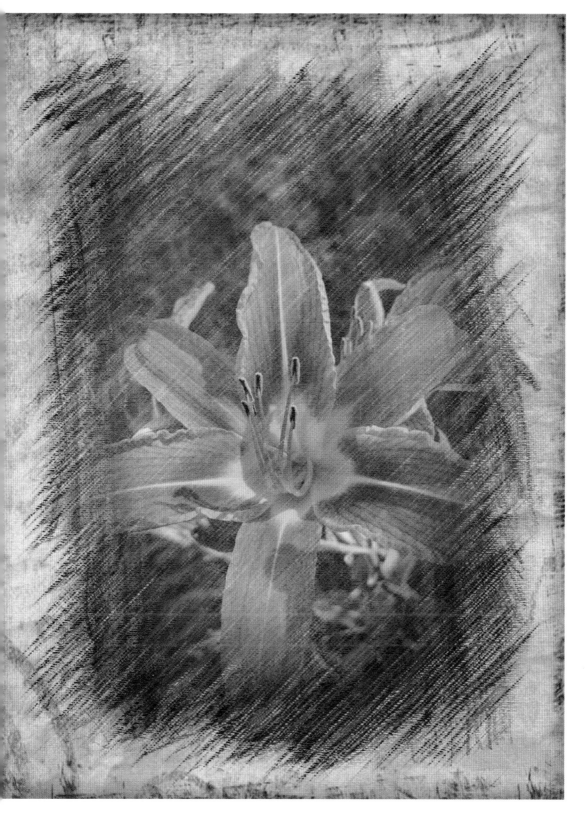

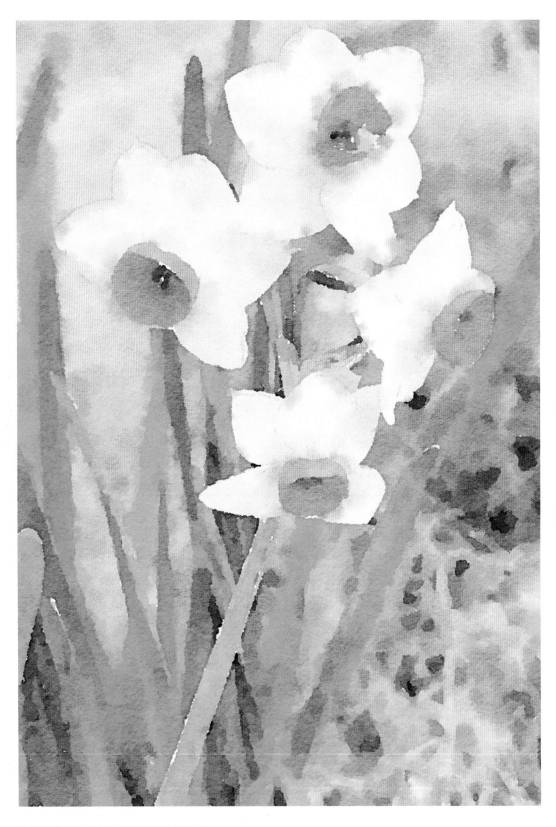

Easy Watercolor

Digital watercolor painting, like digital drawings, have their origins in the traditional media. The nuances an app produces and its success among users are up to the app programmers. Somehow they need to make the app create digital media that simulate the traditional watercolor paintings. Typically the watercolor medium uses translucent paint that employs the white of the paper substrate to portray the white and luminescence of the subject, and pale colors are a result of adding water to dilute the pigments. The images made in such an app will be different than the outcomes of an oil painting app, where the translucent pigments are not typically part of the oil-paint medium. Knowledge of the subtle distinctions of various traditional media is necessary for the development of apps that simulate conventional painting.

I chose a photo of white-petal flowers for this artwork *(facing page)* because white space is so characteristic of traditional watercolor. I've noticed that the Waterlogue app and other watercolor apps do not always create enough white unless it already exists in the photo as solid white. I feel the image is successful.

I created the image *Fungi Growing on a Tree (below)* also using the Waterlogue app. If I desired more detail than this app could produce, I could import the image into another app such as Procreate. Then, I could use one of the many brushes that replicate the action of a watercolor brush. The Waterlogue app fits the bill of a fun and easy app. And I am happy with the colorful results.

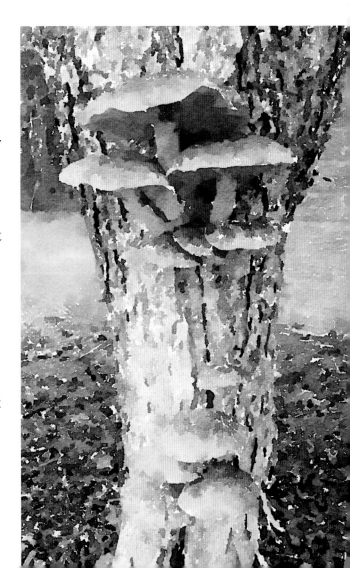

Presets with Refinement Tools

The app BeCasso has so many different looks and styles that it's difficult to choose. Keep in mind your desired artistic effect because

"Get to know your app's refinement tools."

there are so many choices of presets styles. The stylized categories are Artistic, Magic, Colors, and Custom. Within each of these are many presets called Effects. The Artistic Effects tools permit further refinements of Details, Softness, Relief, Brush Size, Brightness, Saturation, and Contrast. The Magic Effects tools allow refinements

of Intensity, Color Transfer, and Softness. The Color Effects option lets you increase or reduce the intensity of a color effect. The Retouch option works with each of the three effects tools to give you the ability to use your finger or a stylist in specific areas of the image. Being able to work in particular areas of the image to accent or vary the effect makes the app very functional. The option to reduce the intensity of an effect is especially worthwhile for those who strive for more photorealism and want to be less painterly or graphic in style.

One pitfall of using this and similar apps is using the presets without refinement. After a preset selection, the amount of control, creativity, and sophistication with the tool use is transformative. Get to know your app's refinement tools.

 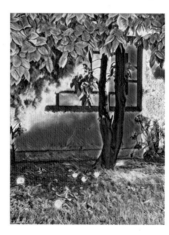 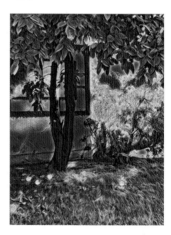

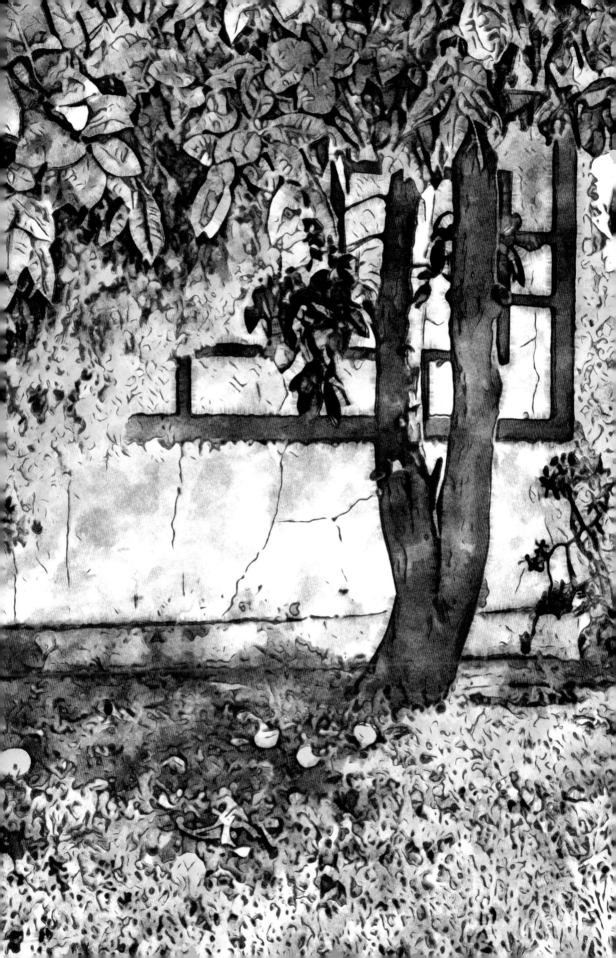

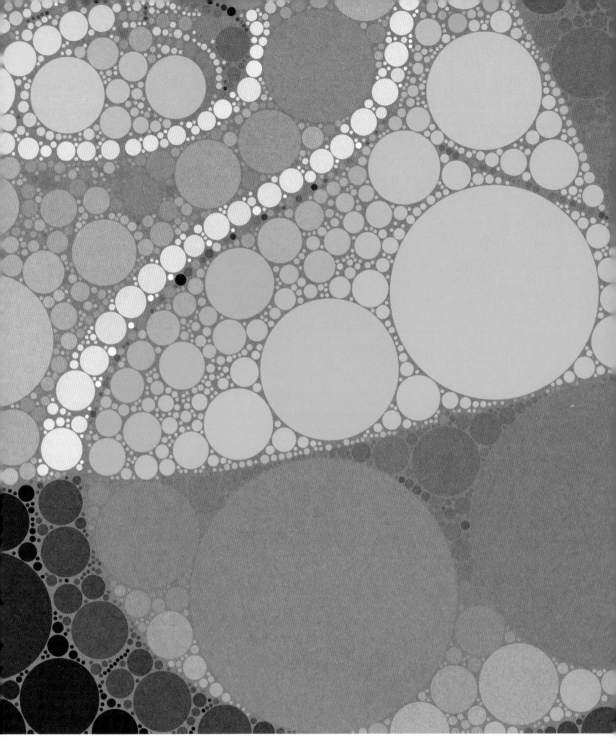

Easy Apps Create
Outstanding Images

vantage point. Once imported into an app called Percolator, it becomes a very eye-catching work of art *(left)*. The different-sized circles look like bubbles, which tie into the water theme subject. The various-sized circle shapes are throughout the image's picture plane, which achieved a degree of cohesion, improving the abstract composition. Notice how the

"Not all images will be what you want."

app loosely distinguishes the photo's initial shapes when overlaying the circles—strengthening and emphasizing the abstract elements.

The Percolator app is easy, fast, and fun to use. Not all images will be what you want. Like many of the uncomplicated apps, play around until you see something you like.

This photo of a pool *(below)* taken from a second-story landing is interesting in itself because of the high

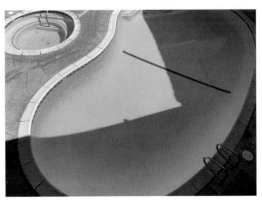

Adobe Capture

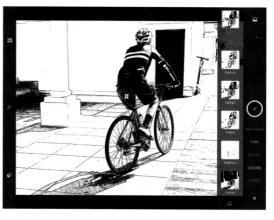

Adobe Capture is one app in a suite of Adobe apps, which include Photoshop Mix, Photoshop Fix, PS Express, Lightroom, Adobe Fresco, PaintCan, and more. Adobe Capture can gather information about colors, type, patterns, and more. With this image of a bicyclist, I used the Shapes option to capture the shapes within a photo *(bottom right)*. Photos can be imported from a phone album or taken with the app camera. A slider allows you to choose more or less black. There is also several presets selections *(see screenshot, top right)*. There is also the option to erase with your finger or a stylist portions of the black *(see screenshot, middle right)*. The file exported can be a JPG or SVG. Adobe Capture creates a simple drawing-type image from your photo. This app is ideal for creating linear or silhouette images. Sometimes something simple is all we need. I have imported this app's files into other apps to use as a mask for applying effects on parts of an image while excluding

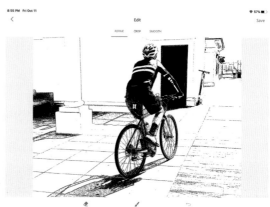

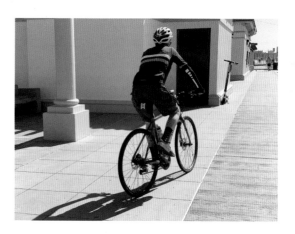

other parts. Although this app is easy to use, techniques that include other apps can make images with more complexity.

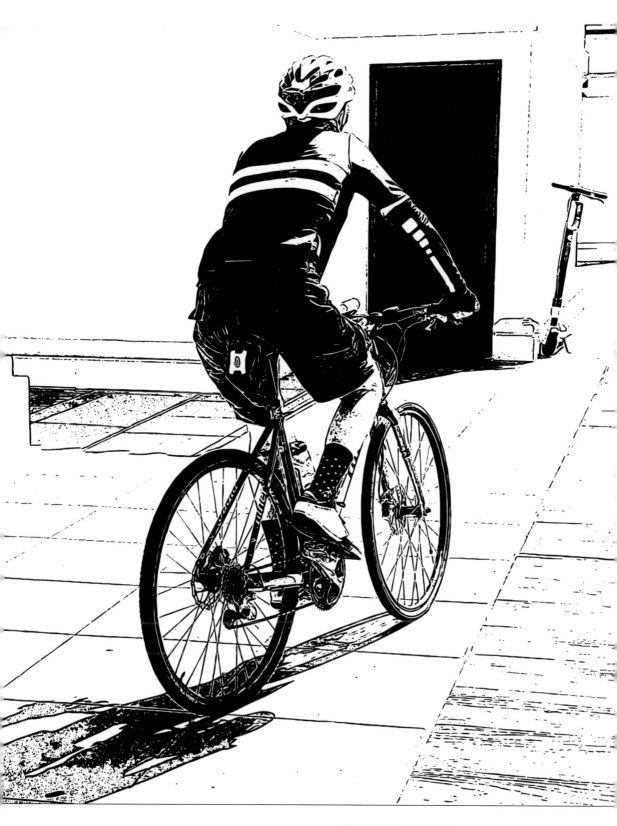

Paint—then Adjust in the Native Photo App

shot, bottom right). The other adjustments in your camera's native photo app, such as saturation, contrast, and sharpening, are also easily applied.

This landscape of a church and its grounds was chosen among numerous images at the same location to avoid power lines, traffic, graffiti, and other distractions. The original photo *(bottom left)* was cropped and then imported into the Glaze app *(screenshot, top right).* I chose and exported several styles. The final image *(facing page)* is attractively textured and painterly, but it needed some lighter areas to be brighter, using the innate phone app *(screen-*

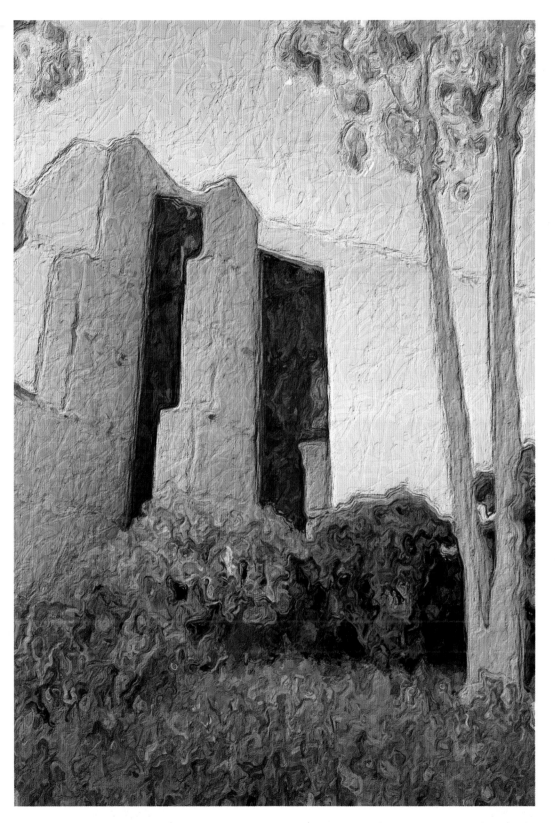

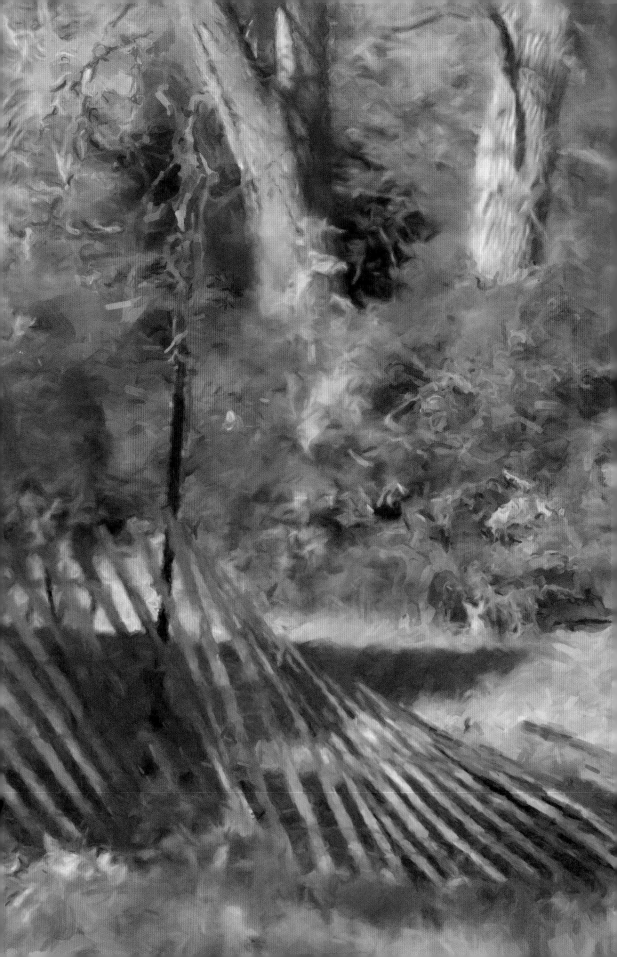

Refine and Critique, Then Repeat

Refining and critiquing is a part of every creative technique. If your image doesn't end up as you wanted it to, or you are displeased with it, do it again. Start with another copy of the original photograph and go through your process once more. Or maybe it's time to use another app that will give different results. I have reworked this image *(facing page, the original photo is bottom right)* about three dozen times. You will learn more about your artistic intent and more about the app.

I was quite pleased with my first rendition made in Adobe's PaintCan app. However, I discovered that the automatic setting for the output was for a low-resolution file, and I needed to have a larger file. In some apps, the image transformation is a matter of a couple of steps, and easily tracked, then tweaked. The process in PaintCan (and many other apps) is more painterly, taking hundreds of moves in the form of stokes. It is exploratory, especially with the aid of erasure and back buttons. Also, PaintCan appears to apply "new layers of paint" while always referring back to the original photo. The app is deceptively simple and surprisingly tactile—something many oil and acrylic painters yearn for after they have made the transition to digital media. There is a substantial capacity to develop your technique using the PaintCan app, and it will be somewhat reminiscent of a paintbrush. Self-critique and refinement are necessary parts of the creative process that allows this kind of malleable manipulation.

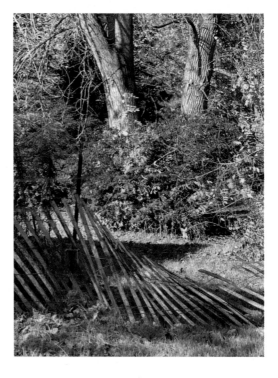

Ink Printing App and Technique

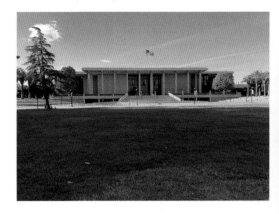

The app Inkwork produces a look in images that is reminiscent of somewhat crude ink printing, such as block printing or screen printing. This app has an easy to use layout *(middle and bottom right)*. The options to change in the Inkwork app are the size of the line, the darker-valued color, the lighter-valued color, basic cropping, and the artistic styles, which vary from almost photographic to cartoonlike to illustrative to minimal and more. There is an option for images to be exported as JPG, TIFF, or PNG files.

The images produced are often delightful, subtlely capturing gestures of movement in the photo. Notice in the final image *(facing page top)* the characters of the tree and the flag expressed with simple lines. Deceptively simple, there is a technique in creating a finished work. The four smaller images on the facing page are a sample of the dozens of variations I tried before I got the final one. Again, the artistry is in knowing what your image's

purpose is, deciding on a style or genre, knowing which tools to use, having the skill to use those tools, and putting in the time to explore with those tools in a creative process.

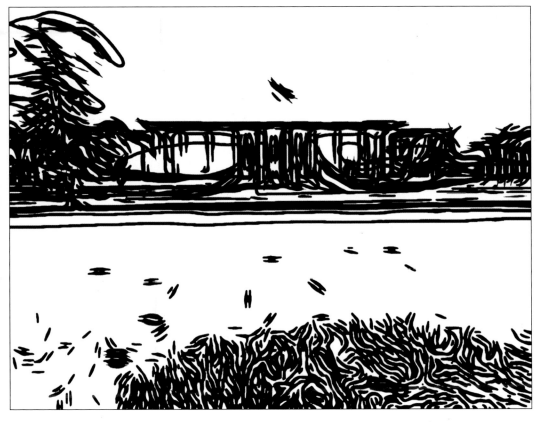

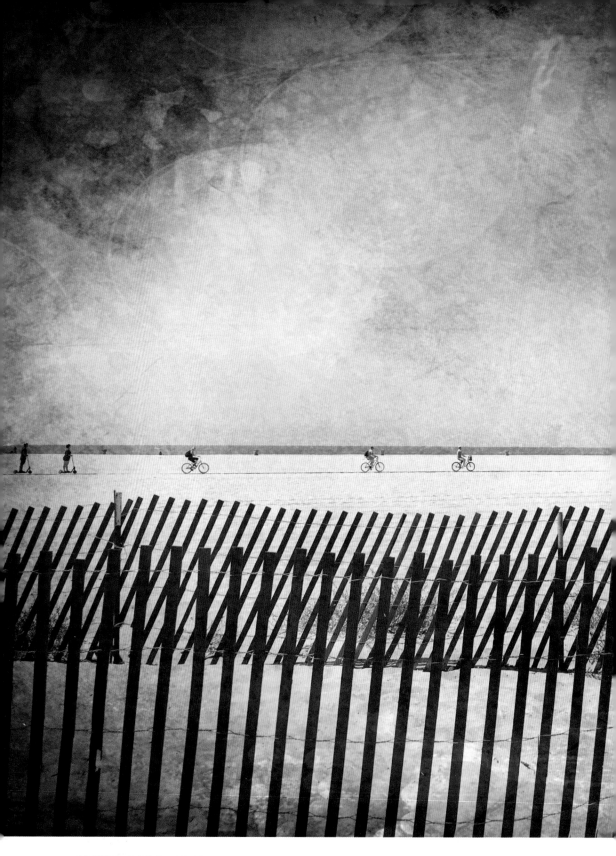

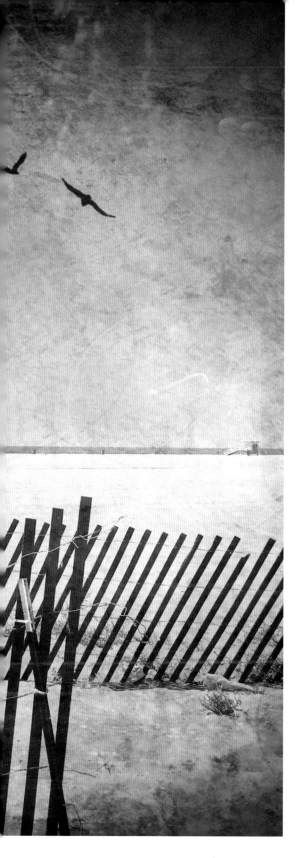

DistressedFX+

DistressedFX+ is an app that effortlessly transforms your photos into atmospheric illustrations. The app works particularly well with landscapes and big skies. Import a photo. Then choose two separate overlays *(see screenshots below)* to put on top of the image applying atmospheric qualities. The possibilities are endless. Adjustments help to finetune the overlays chosen. Add a flock of birds too. There are several different flocks provided. Positioning and opacity adjustments of the birds are possible. This app is simple but remarkably transformative.

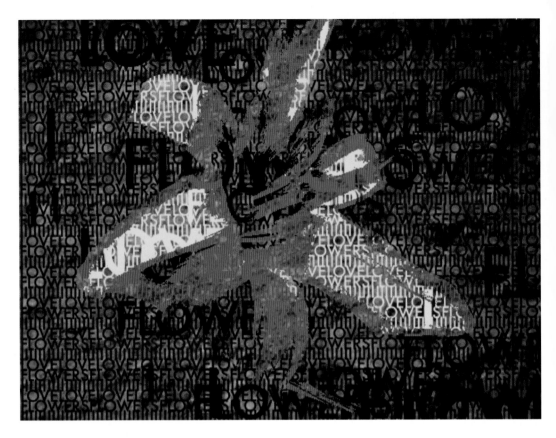

aType Words into Images

These are images made with an app call aType programmed for an early generation iPhone and iPad. The app and several images are included in this book because it's fun and easy to use. It combines words, entered into a list, with a photo and a texture. A kind of word cloud is created and combined with any photo you choose. The images have structure because of the graphic nature of type. It also produces images that are very painterly meshing with the type whichever photo is used. It generates images quickly and with few steps. The most challenging thing is deciding which color scheme to use.

Unfortunately, aType is not updated to work on newer Apple devices, and maybe the programmers never will update the app. That's one reason I keep my old devices rather than turn them in. My old iPad still works, and it's the only place to use legacy apps that are still quite functional.

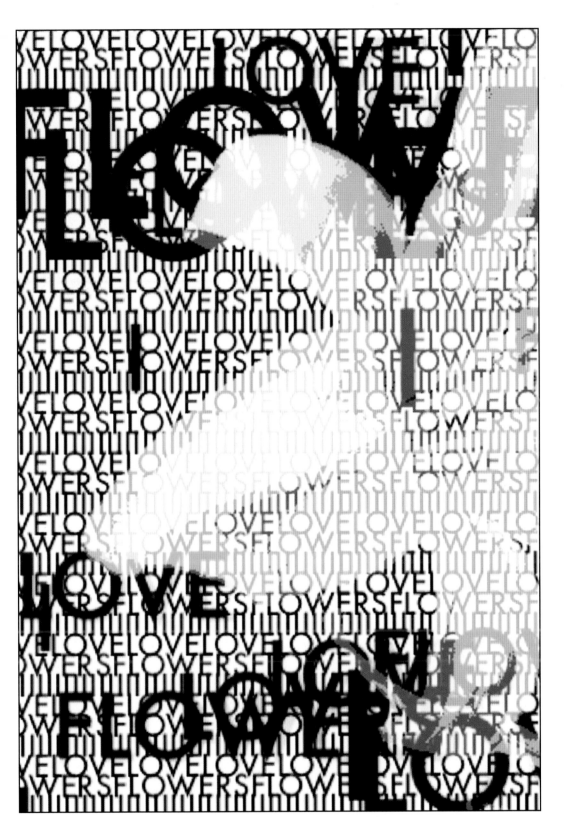

WordFoto

After writing about the outdated aType app on the previous pages *(66–67),* I looked for a similar app and found WordFoto. This app looks promising. The cat image is the first one I processed in this app. First, I used the SnapSeed app to crop the original image. Next, I selected a SnapSeed preset that lightened the edges. Lastly, I imported it into WordFoto, typed in the words "MEOW" and "purr," and then exported it.

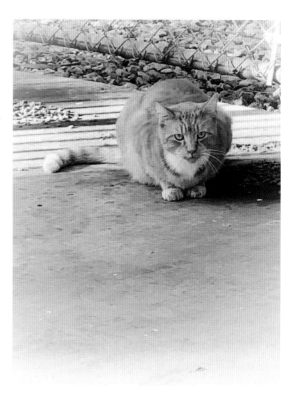

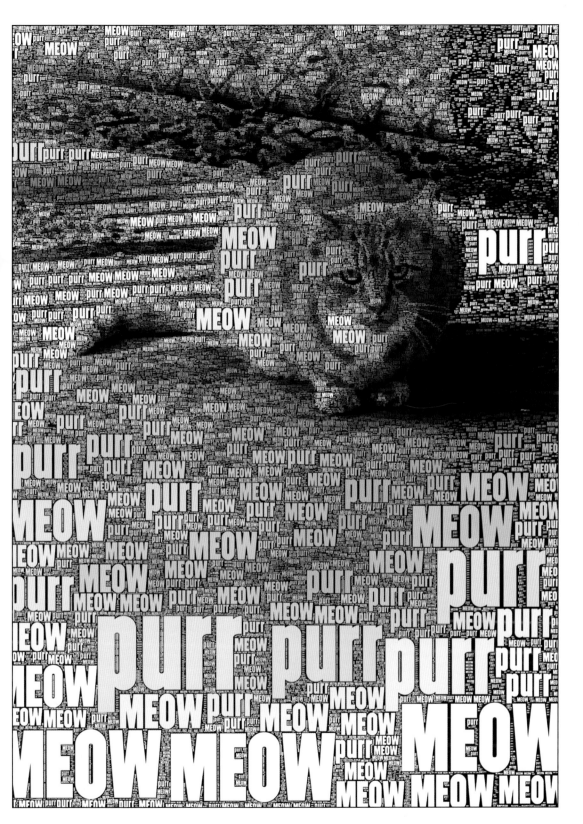

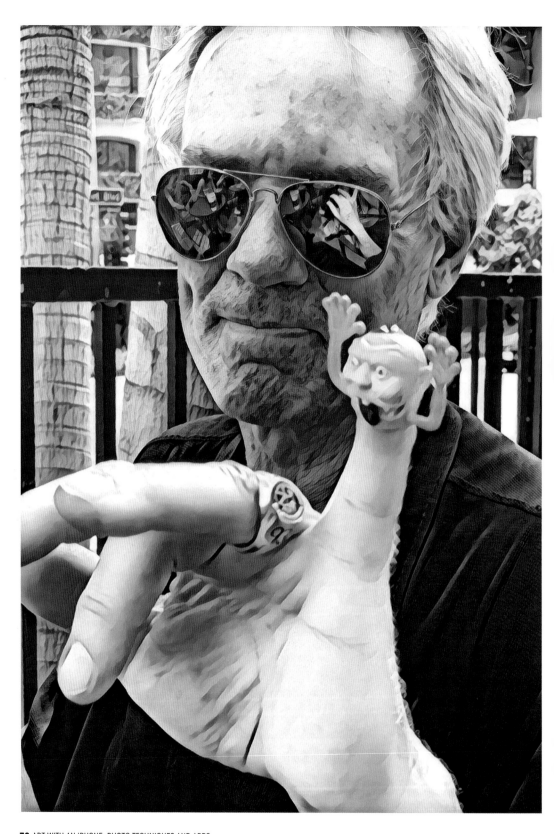

Finger Puppet Portrait Style Choice Explained

Most apps can easily and quickly give you many variations of one image. So, decide what it is you want your image to say to the viewer. What is its purpose? Does it need to look like a folk painting, a playful line drawing, or a faded photo? Determine what kind of image you need for that purpose before being challenged with the abundance, which most apps produce.

When deciding which rendition is the right one, think about what you want to be part of the image. Don't get caught up in colors or styles that can call to you like the sirens. Honestly, sometimes I feel like the color magenta is tracking me where ever I go—whichever app I'm working on *(bottom left)*. I like the dark image *(bottom right)*, but it is too ominous to portray as celebratory. The original photo did document a birthday gathering in a coffee shop. So, I wanted to show the other people attending the occasion by putting them in the sunglasses reflection. The final image *(facing page)* is cheery and has a good rendition of the reflected figures, but the other two don't. This image succeeded in doing that.

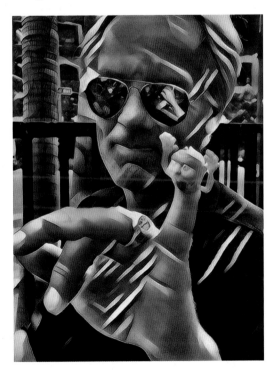

Effortless Variation with Presets

I imported my iPhone photo into the Adobe Photoshop Express app. The app has numerous presets called Looks, many of which are free. A monthly or yearly fee makes additional presets available. The variations are effortless and incredible. The presets can boost color saturation *(top right),* create a black & white *(facing page, top left),* or a black & white with green foliage *(bottom right).* A grunge overlay makes the photo look old and tarnished *(facing page, top right).* Each of these presets are modifiable with a variety of adjustments. Another category called Themes offers more presets, some of which have type options that are great for instantly creating posters, covers, labels, and packaging. Both the Looks and Themes options lets you make and save your own presets.

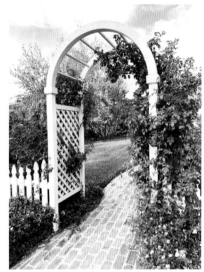
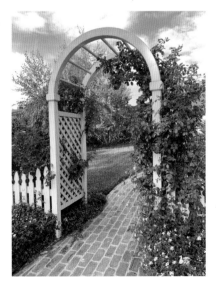

5 Double Exposures, Layers, and Masks

Creative layering and masking techniques transform your iPhone photos into spectacular art images.

Double exposure originally meant exposing film twice with the effect of two unrelated or unexpected images combined into one. Sometimes these images had a ghostly or supernatural appearance. Often double exposures shot with as film were accidental. When executed purposefully and correctly, strict calculations are needed for camera exposures to be successful. The double exposure technique is extensively creative when using digital cameras, apps, and software.

Double exposure functions in apps typically combine two images. Apps with layer functions are needed if more than two images are to be integrated. My two favorite apps for layer functionality are Procreate and Adobe PhotoshopMix. The advantage of working in layers compared to the double-exposure technique is that generally, each layer can have a blend mode. Blend modes determine how the pixels of one layer will mix with pixels of a different layer. Layers give important creative control over how our final images will look.

Masks are yet another tool for image control and creation. Masking lets one portion of an image to be transformed by a process, filter, or technique while allowing the remaining part to remain unchanged. Masking is complex and not always a simple step or two. Depending on the app, options include using a digital paintbrush, rapid selection tool, or pixel selection to create a mask.

Double exposure, layers, and masks technique options are in many apps. You can use them even after first processing your images in some of the more effortless and speedier apps.

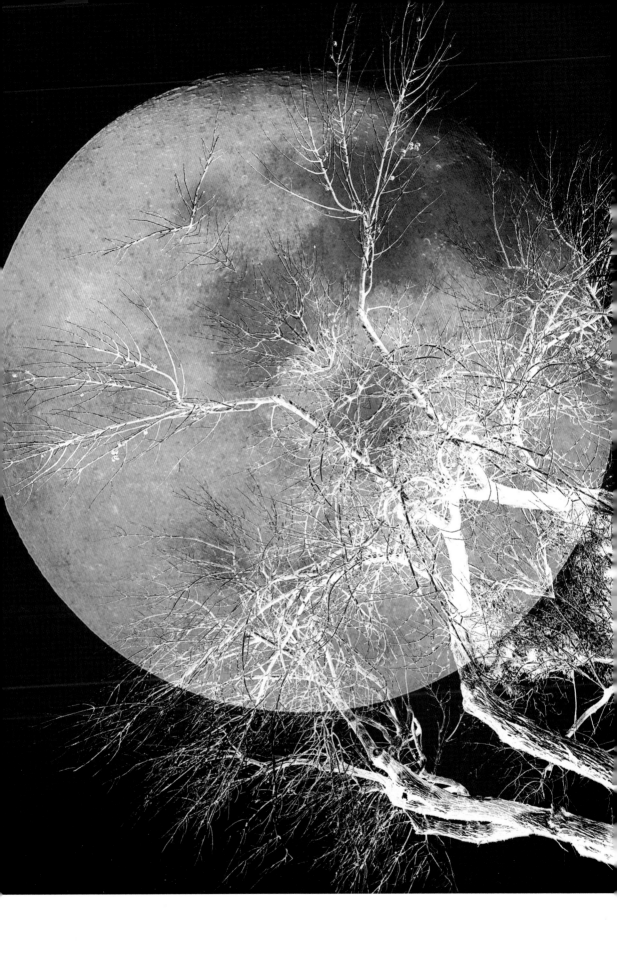

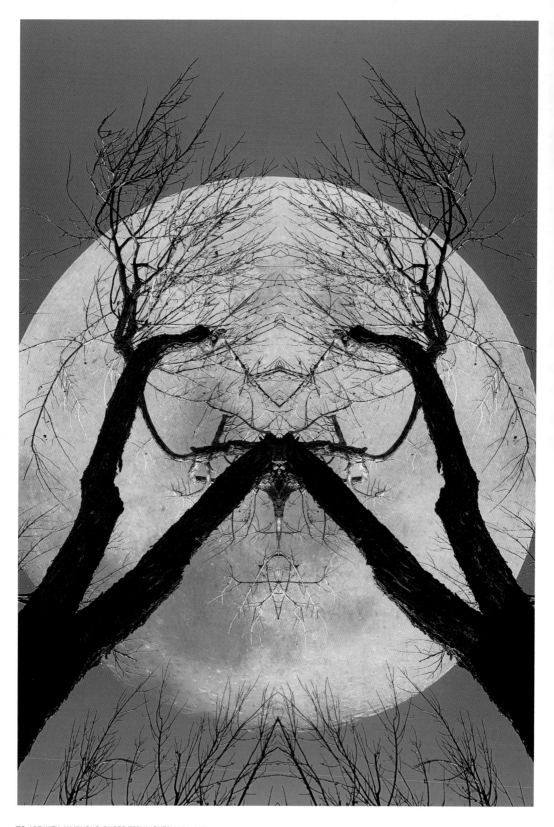

Snapseed Double Exposure

These moon and tree images each started as two separate images. The moon file is a public domain image from a NASA website. My moon photographs were too small, even when taken with a telephoto lens. The tree photos, taken in daylight against a bright sky, appear as partial silhouettes. Nception often creates a curious and often unnatural-looking symmetry. These images have an other-worldly flavor. I opened the moon file in Snapseed and then selected Double Exposure. It prompts the user to open another image file— a tree in this case.

In Snapseed Double Exposure, the amount of contribution from each of the two images adjusts with a slider. The leaf image, where one leaf is more dominant than the other, shows the impact of these adjustments.

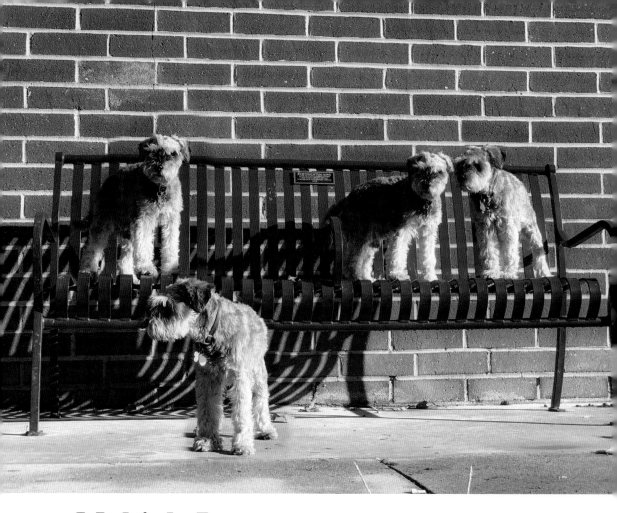

Multiple Layers: One Dog Makes the Pack

This creative technique is loads of fun and can enable a ruse. This photographic image, taken with just one dog, looks like there are mul-tiple well-behaved canines. And all you need is one willing, well-mannered pup.

The technique requires you to set up your camera phone on a tripod. I used a fourteen-inch flexible leg tripod. I used four photographs for a merge, so it was essential for everything but the dogs to remain the same. The bench bolted to the

 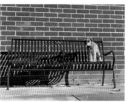 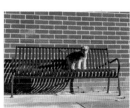 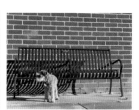

sidewalk could be counted on not to move. I also employed a remote shutter because touching the screen will knock the camera's alignment. Consider taking one shot with no subject in it. Try to have the same lighting in every exposure.

I imported the four exposures into the Adobe Photoshop Mix app, each shot on its separate layer. Double click on the layer icon to get a slider to reduce its opacity *(top right),* revealing your subject's different positions on various layers *(middle right).* I made sure the dog on one layer didn't overlap with one on another layer. Then, starting with the top layer, I chose the Cut Out option *(bottom right).* A variety of tools lets you select your subject. After pressing the check icon, everything but the selection gets deleted. Do the same for all layers except the bottom layer, which will provide the background. If you have a shot that is without your subject, this is ideal for a bottom layer.

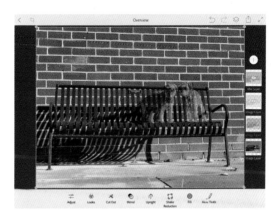

There is an option to save the file with all the layers intact. This choice requires more memory. The other option is to flatten the layers. Either choice lets you export a new JPG file to your Photo album or another app for further refinement.

Vignettes Made with Layers

Vignettes can be added in a phone's photo editing app or third-party apps. Adding a vignette to an image is fun, quick, and easy. Each app does it differently. Some darken the edges. Some can lighten the edges. Some allow a shift in the center point. Some will even let the outer drop out of focus. Each has the effect of drawing the viewer's attention to the center of the image. An app with layers is multifunctional. The kinds of vignette possibilities are infinite. For example, import the original photo for the initial layer. Then import a layer that has transformed the original image—for example, turned it into a cartoon style or a watercolor. One of these images will be the central image. The other will be the outer vignette.

For this work *(facing page),* I used Adobe's Photoshop Mix app because it uses layers. The image file opened in this app becomes the first and bottom layer. For this first layer, I used a photo of snapdragon flowers transformed in the Waterlogue app. Then I imported the original photo as I added a second layer. I selected Cut Out to create the vignette *(bottom left).* I dragged my finger diagonally from left to right to make an oval *(bottom right).* The edge of the shape made—in this example, an oval— can be refined to soften. Confirm by selecting the check-mark symbol. Then export the image.

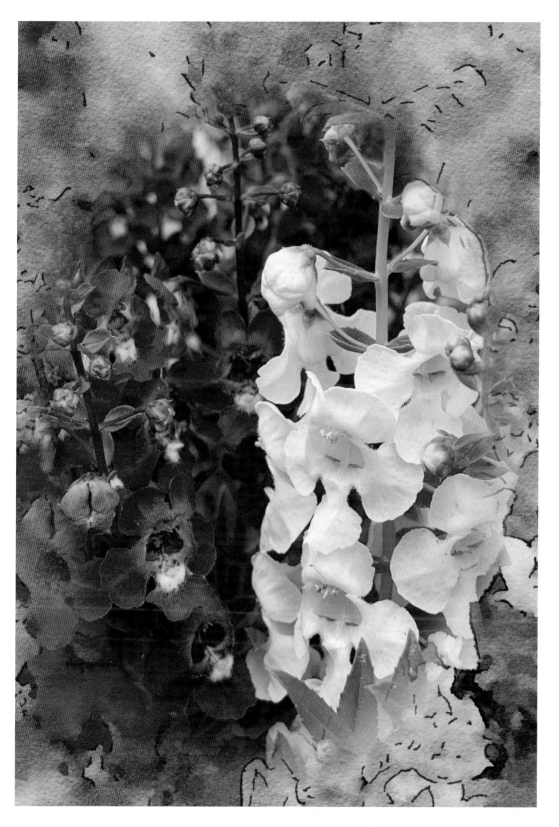

Paint a Mask

The Glaze app for painting has a paint mask feature. First, chose a paint preset. Then, select the Paint Mask icon (*facing page, top left*) for the ability to paint the areas to be "painted" and which areas will be left unaffected. The

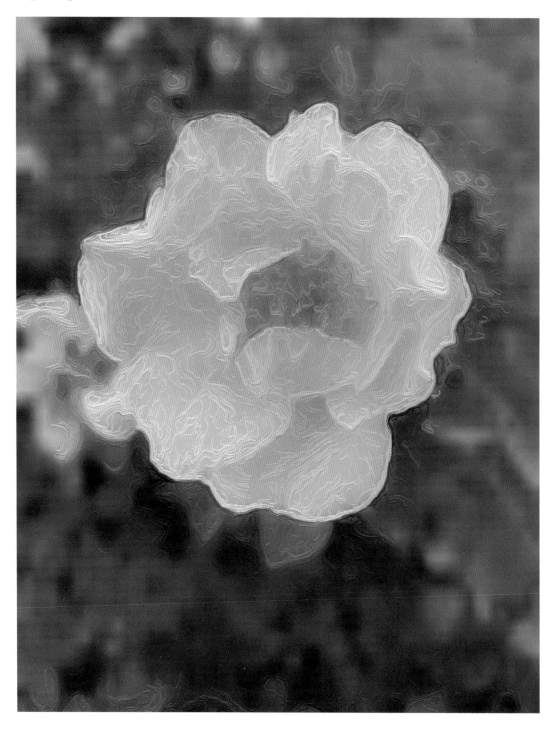

mask, indicated by a transparent yellow-green color, is visible. The technique was used for the final image *(facing page)*. Notice how the untreated background area remains photographic, while the masked areas are treated with the painterly preset.

Another option is to select the Transparent Background icon *(middle left)*. Now, only the effects of the masked image are seen. Without the original background photo *(bottom left)* integrated, the resulting image is incredibly different *(bottom right)*.

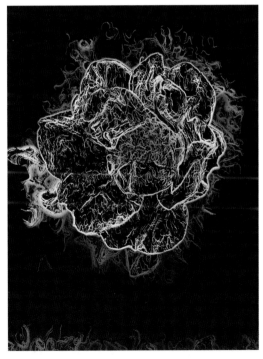

Blending Modes

Blending modes determine how separate layers are to combine. The default mode will show the top layer without any blending with the layers beneath. All the other blending modes have prescriptions on how layers will mix with other visible layers. Here is a list of the principal modes: Normal, Dissolve, Darken, Multiply, Lighten, Linear Dodge (Add), Difference, Hue, Saturation, Color, Luminosity, Lighter Color, and Darker Color. Knowing complicated algorithms doesn't necessarily add to your skill in using them. So, I would suggest exploration using two or three layers in an app like Adobe Photoshop Mix. Change each blending mode to see what it does. Try several images on different layers.

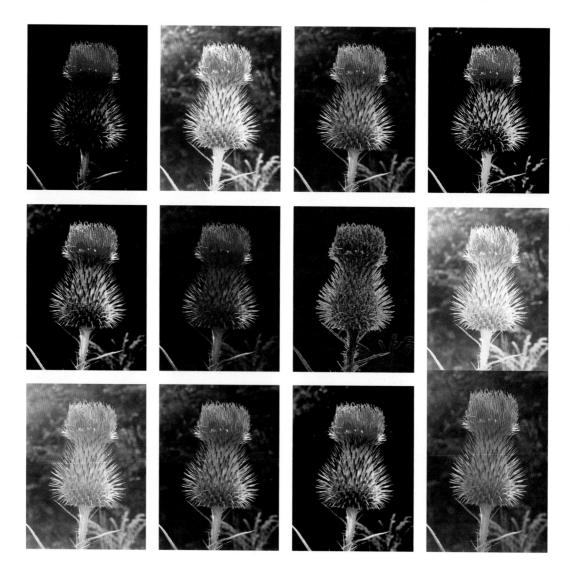

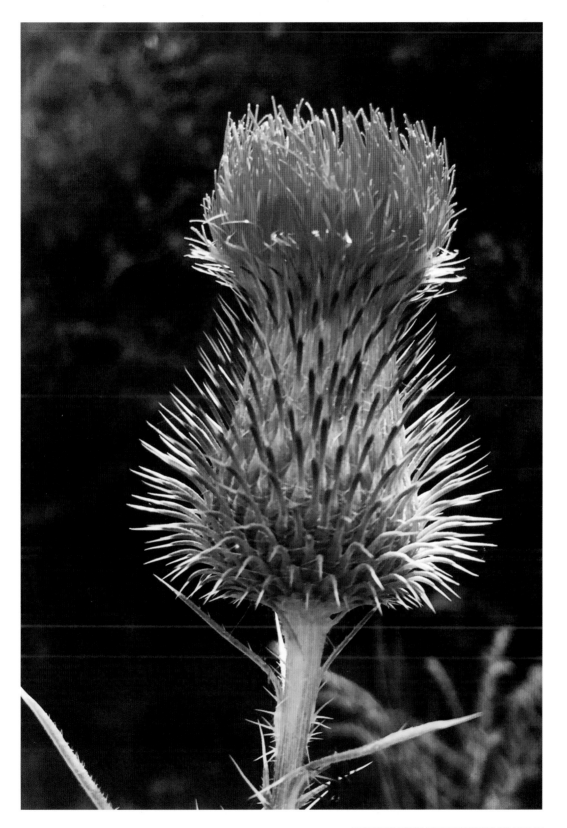

Abstract Portrait Using Layers

The Procreate app is a powerful drawing and painting app that also uses layers. The layer visibility can be toggled on or off, and a handy

> " *Each layer also has twenty-six different modes...*"

slider for the opacity percentage of each layer. Each layer also has twenty–six different modes, which allow each layer to interact with the content of each of the layers in various ways.

This image of a person with a mask and goggles during the recent pandemic uses a total of five layers. The bottom background layer of chartreuse preceded three middle layers filled with various brushwork. The top layer is an imported photo. In the first image *(bottom),* each of the first three layers' modes is a Normal mix mode, and the upper-most layer's mix mode is Difference *(top screenshot).* These mix modes produced a partly photographic image,

which I did not want. So, I changed the uppermost layer to the Hard Mix mode *(middle screenshot)* to achieve a more abstract quality I wanted for the final image *(facing page).*

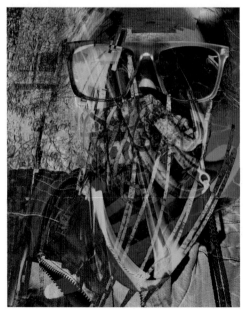

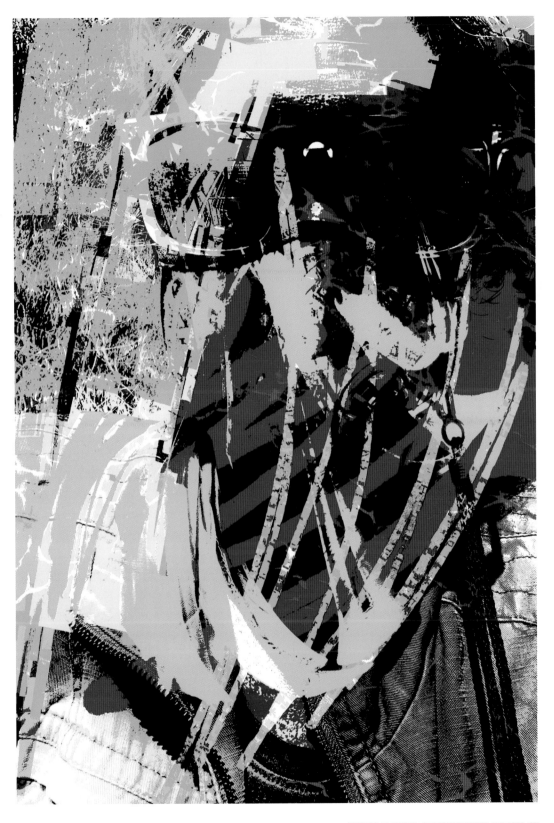

Image with Peek-a-Boo Text

A type effect, like the one used in *SunFlower and Bee,* is made in Snapseed. For this photo, I opened the file in Snapseed. Then, I decided to turn the image into a vertical rather than horizontal format, rotating and flipping it. At this point, I selected the Text tool *(see screenshot, top right)*. There are three main options with this tool: Color, Transparency, and Style *(see screenshot, bottom right)*. There are many styles to choose from in the Text tool. Next, do a double-tap on the screen to type in your message. The text rectangle can be repositioned and resized with a two-finger touch. Creating the peek-a-boo effect is simply a matter of selecting the Transparency option and then Invert. Adjust the transparency using the slider. Use the Color option for either the letter color or use the Invert effect to color everything except the letters.

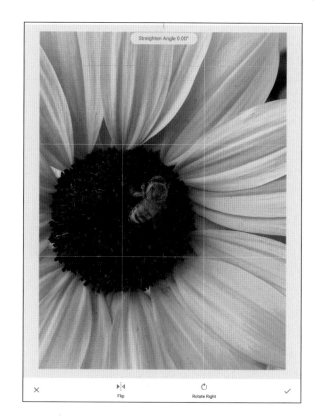

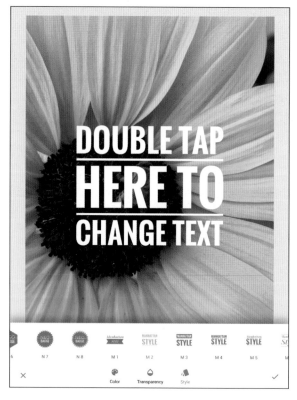

SUNFLOWER AND BEE

6 More Creative iPhone Art Techniques

A multitude of apps can transform your iPhone photos into all sorts of creative images.

This chapter has more examples of techniques to try. Exploring creative photo apps is contagious. Maybe you're after an app that will simulate traditional film techniques that has film artifacts. Try these apps for interesting film-like effects: Polarr, Darkroom, GlitchyPsyche. Do you want to produce master-oil painter style images, these are some apps to try: Adobe PaintCan, Brushstroke, Oilist, or Glaze. Paintcan feels like you can push the paint around with your finger or stylus. If you would prefer a watercolor style, try Waterlogue. The app iC Painter simulates a variety of paint media.

Would you like to try some surrealist effects? Try these apps: Gloomlogue, Thyra, Fragment, or the BrainFever Media app suite.

Apps that simulate drawings are too numerous to list here. An app called Kansulmager lets you try out your programming skills to change the appearance of your photos. And there are plenty of new and updated apps to explore. Some apps have a steeper learning curve than others. And don't forget that the images you make can always be imported back into a basic editing app to do additional essential finetuning. You will find some favorite apps that will send you down the rabbit hole of endless creativity and exploration. The appendix at the end of the book will list most of the apps that I use. The apps are in general categories of what they do.

Check the image-file export size. In some apps, it is variable. Some apps let you change this setting to

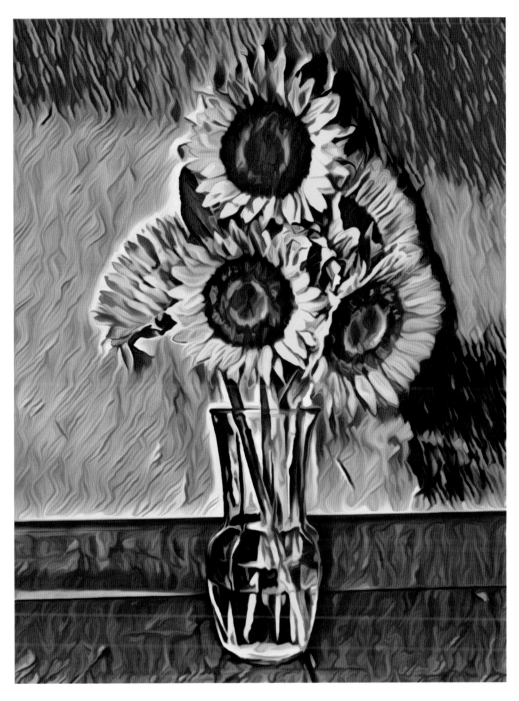

smaller, so the phone's memory isn't overwhelmed. Or change the file size to export as a larger one when printing sizable images. You can make profoundly exquistic images with iPhone apps and creative techniques .

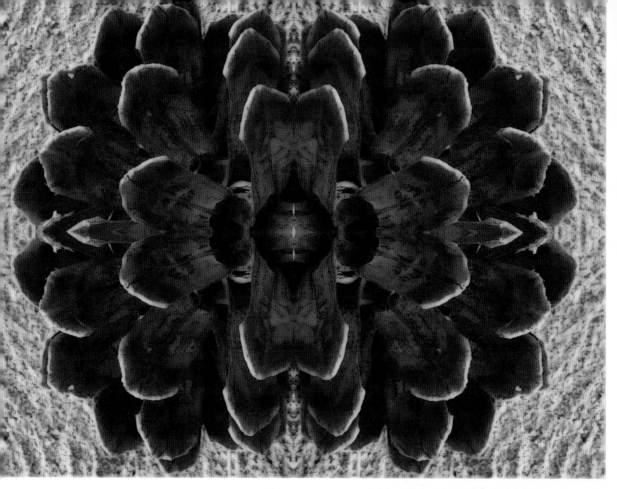

Mirroring

This simple photo of a pinecone on a sidewalk is transformed in the app Gloomlogue, first in its graphic style *(right, screenshot)*. The app does many things, but its mirror option *(facing page, upper left)* is hard to resist, and it offers numerous possible variations *(facing page, upper right)*. Illustrated here *(above and facing page, lower four images)* are just some of the reflection possibilities of the mirroring

 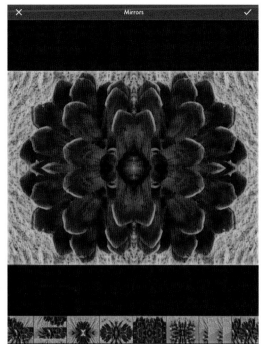

tool. Initially, symmetry is apparent in the images created. But, repetition and rotation are also. This app

can be a wonderfully creative tool to spotlight detailed curios or to make unusual portraits.

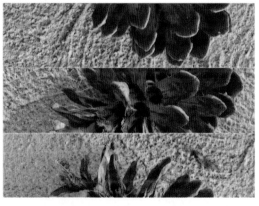 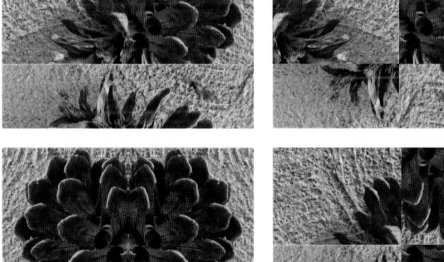

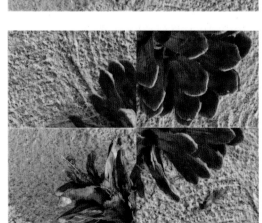

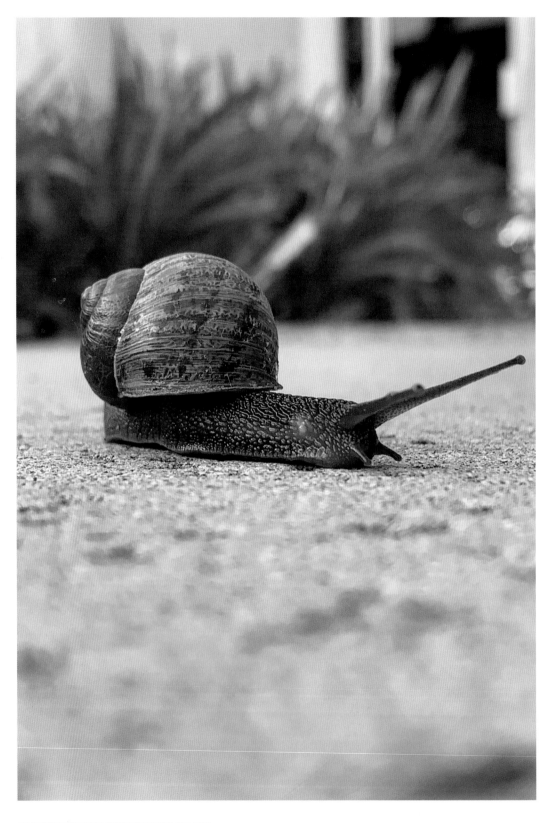

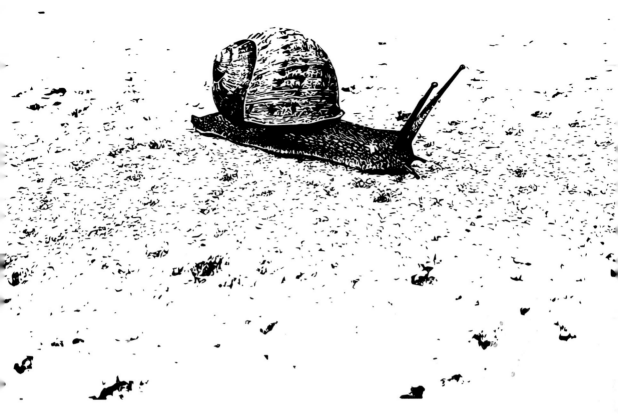

More Adobe Capture for Shapes

The Adobe Capture app does many things. For this black & white image, a silhouette-like image was be made and refined depending on how much background or detail I wanted. The app captures shapes from a photo. My purpose for using the Capture app is to take a realistic photo and turn it into a simple image made of shapes. The shapes and their placement can be symbolic of an animal or object. Simplified representations used to print on clothing, illustrate in single-color printed books, or as icons for a website, are often made from Photos formed in this way. Photos can be beautiful. However, sometimes all that is needed to communicate an idea is a picture made with a few shapes placed in the right place.

Note Taking and Breadcrumb Trails

The abstract quality of this image is impressive, and I would like to reproduce it with another subject. But, I need to experiment all over again

because I lost track of which apps I used. So here is my advice. When you are working, take notes or leave a breadcrumb trail so you can duplicate a productive technique. Working in a creative series, it is especially crucial. Using the same apps, subjects, and processes for a group of images will make them into a cohesive set—a creative series.

My current routine for keeping track of which app has been used for a particular image is to take a screenshot of my open apps. Usually, on my phone, the most recently active app is in the upper right. This screenshot goes into the photo gallery along with this session's completed images. Also, on exporting a file, some apps will attach additional metadata. Apps such as EXIF Data or ImagExif will help you read the information in an image file metadata. And of course, if you want to take

additional notes in a note-taking app, they can be helpful, too.

I started by cropping a photo to include the only portion I was inter-

"Using the same apps, settings, and processes for a group of imags will make them into a cohesive set."

ested in, the landing bird and its extended wings. I must have processed the image in an app that created a fractioning effect, like Gloomlouge or Thyra. Then, I probably loaded it into an app called Fragment to get the circular mandala effect.

The original cropped image *(below)* of the raven appears in grays. What I can't reconstruct is how and when I introduced the color scheme. Most likely, I introduced a new layer with selected blending modes, such as Difference or Exclusion, which introduced color. Good note-taking is a practice that takes the guesswork out of duplicating technique that creates a unique style or appearance.

Adding Textures

I worked this image in the same manner as the piece described on the preceding pages. I wanted to

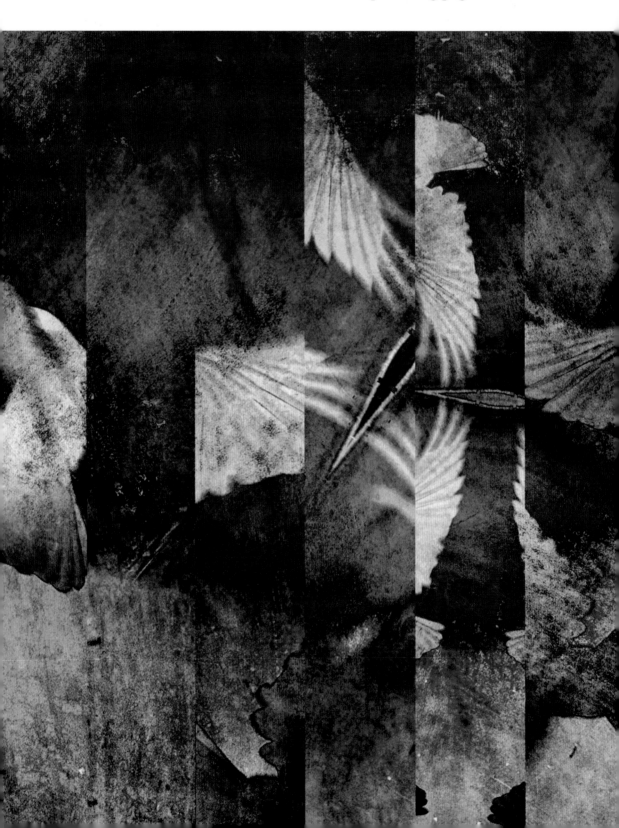

introduce color and texture because it was pretty much shades of gray. I used an app called MOLDIV that has an option to add textures. As can be

seen in the screenshot of the app in use, these texture overlays include color. Because one of twelve color modes can be applied to any texture, a significant number of variations are possible. The transformation from a predominantly gray-toned image to a vivid yet subtly colored final image is surprising. MOLDIV has lots of textures. But if you want to use your texture files, an app like Adobe Photoshop Mix uses layers with these same color modes. First, open your image onto the first layer. Second, import your texture file into a second layer and experiment with changing the color modes.

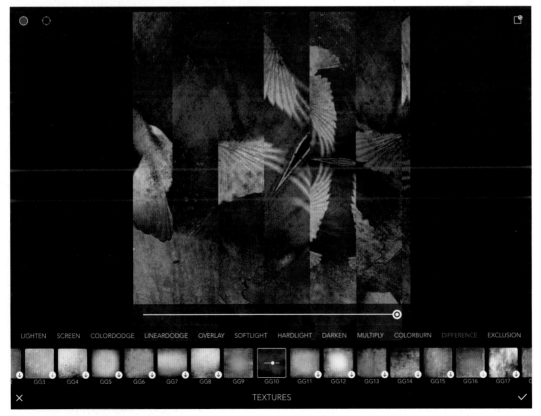

Grunge Filters

This is a photograph of steps up to a train platform. The sweeping curves add beauty and elegance despite the graffiti on the upper landing. The railing's shadow is interrupted only by the rising steps, which seems to emphasize the emptiness of the place between train stops. It has a moody feel, but the blue sky, rosy shadows, and texture (added in the SnapSeed app with a Grunge filter) keep it from being too gloomy.

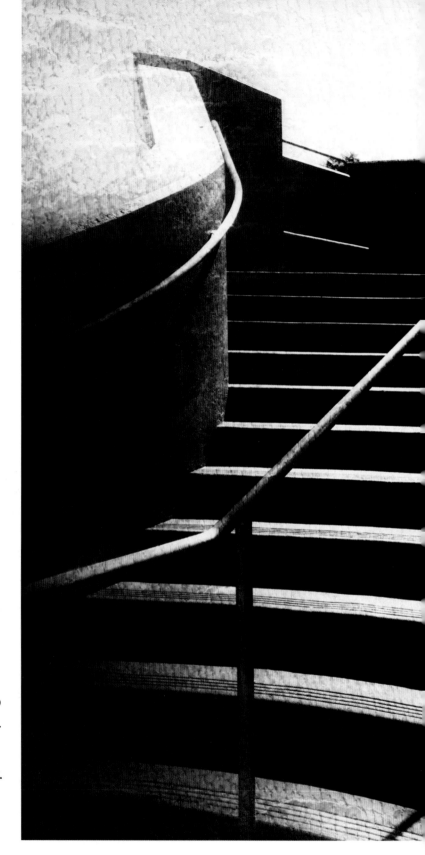

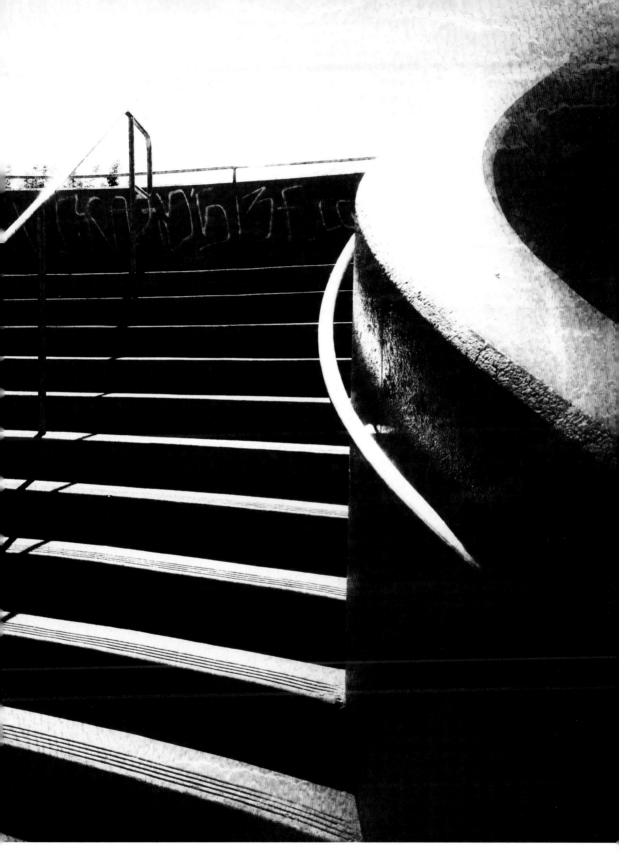

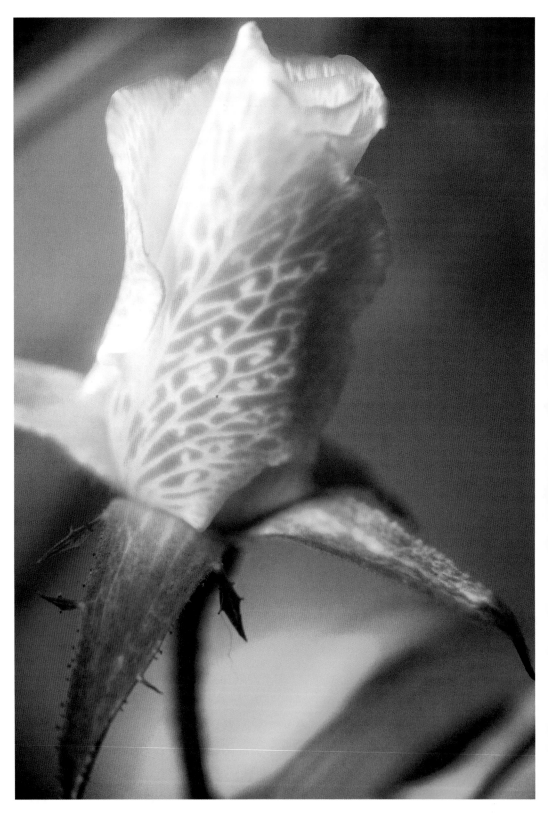

Ultraviolet Flower Fluorescence Technique

This rose, photographed under ultraviolet light *(facing page),* is not bioluminescent, a kind of phosphorescence—where it emits its light, like jellyfish or some fungi. In creating this fluorescent effect, I drained pyranine from a highlighter marker and put it in the flower water. The flower drank up this mixture, concentrating the pyranine in certain areas, most notably the petals.

Then I lit the flower with ultraviolet lights. The flower emits, or maybe more accurately reflects, the light in a longer wavelength, which unlike most ultraviolet light, is visible and recordable by a camera phone. The process is called fluorescence.

Besides photographing under ultraviolet light, the rose was also photographed under typical indoor lighting *(bottom right).* The only post-refinement to the ultraviolet image was a small adjustment to the white balance in the Adobe Lightroom app *(top right).* The point of

this example is that even if the principal creative technique for an image is outside of your iPhone, routinely, an app is still needed to tweak the image quality.

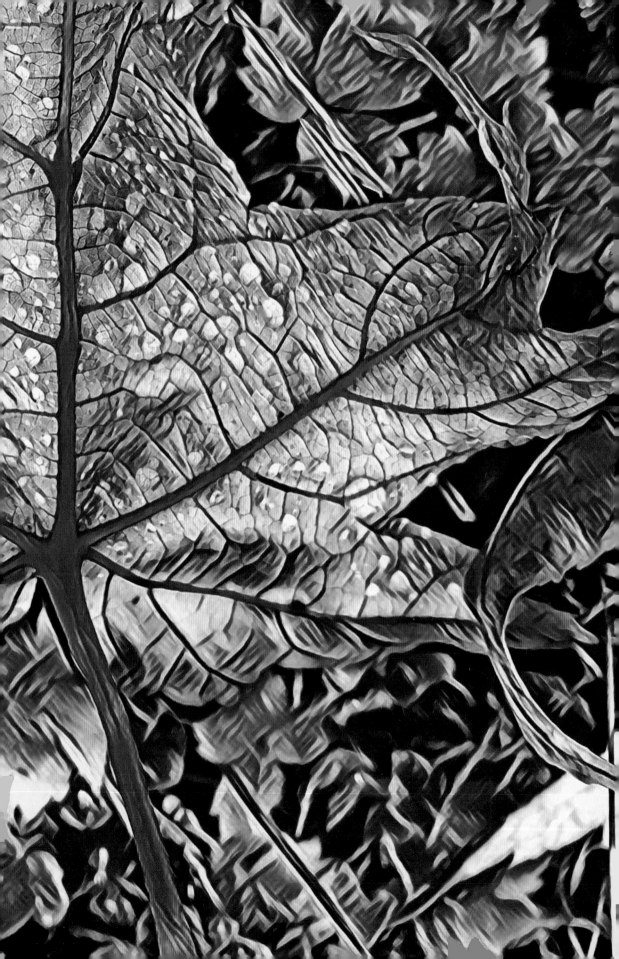

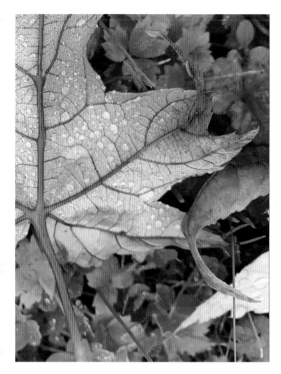

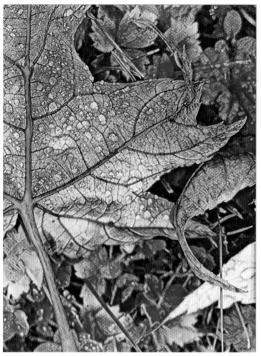

Graphic Leaves

The original photo *(top left)* is of a red leaf fallen on green clover and covered with raindrops. I used an app called Picas. The simple app is designed strictly with presets. The only adjustment is the degree to which the effects are applied to the photo. It is interesting to note the difference between the two presets *(facing page and top right)*. The preset seems to have identified the leaf's veins as the subject, and all else in the photo converted to gold. In the other image, the preset has main-

tained some of the original colors. The Picas app has over one hundred graphic styles from which to choose.

"The preset seems to have identified the leaf's veins as the subject."

Each quite distinct and different from the others. Remember that once you've created your artwork, importing it into other apps lets you finetune and modify the saturation, contrast, or other elements.

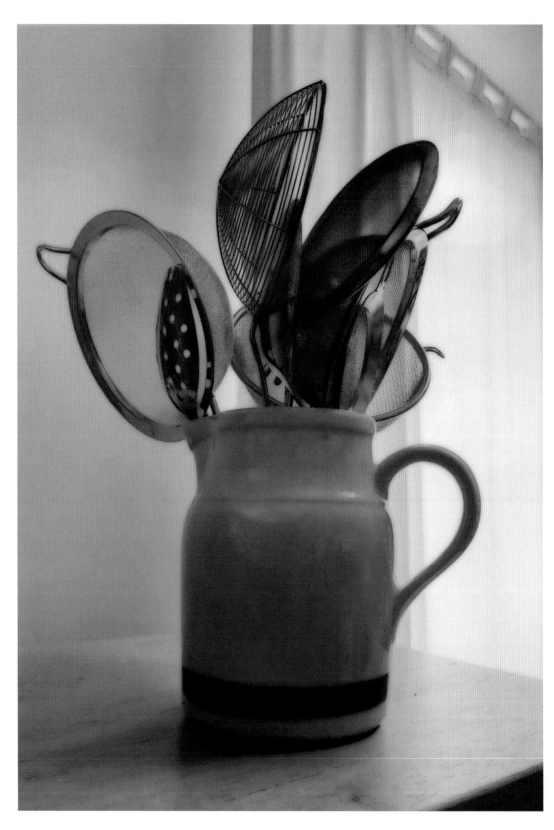

Bokeh Effects

Boheh, a Japanese word, refers to a softening of the image, and in the beginning, referred to film cameras,

"Digital media has expanded the notion of bokeh to include additional, often subtle effects."

an effect resulting from a camera's lens or its aperture shape. The result is an area of a blur. Digital media has expanded the notion of bokeh to include additional, often subtle effects.

The window in the background of the image *(facing page)* is slightly more out of focus than the original photo *(bottom left)*. I opened the image file in an app called Gloomlogue. It asks the user to choose a filter and gives a slider to adjust the amount of its effect. Then, among many adjustment choices is one for bokeh *(bottom right)*. A row of bokeh choices is below the app's image window. There is also another slider to adjust the amount of the bokeh effect. The final image has a reduced amount of bokeh. About one-third strength was applied—just enough to affect without it being obvious. Numerous apps have a bokeh option, although some may not refer to it as a bokeh.

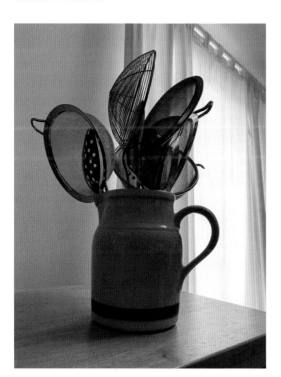

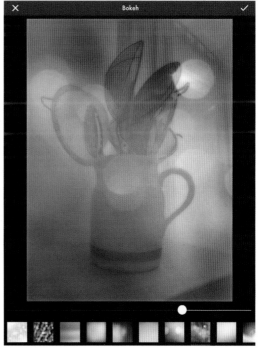

Composition and Maximizing the S Curve

Here is another example of using more than one app to develop an image. I used Adobe Photoshop Fix to increase the saturation *(bottom right)* because I wanted more intense color. To make the s-curve of the blue carpeted walkway more prominent, I intensified its blue. I find it better to change these elements before working on an image in its final app. Then I imported this image into BeCasso *(top right)*. I choose the artistic set of styles *(middle right)*. The Artistic set includes many oils, watercolor, and drawing options. I intended to create a David Hockney-like image that emphasized color and a liquid feel. The s-curve is prominent and repeated in the sand marks. Using the rule of thirds, I placed the horizontal water line at the top third. And although the cluster of people isn't placed at the top-third and left-third line intersection, their continued motion would position them at that key point.

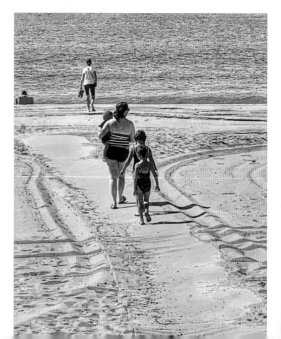

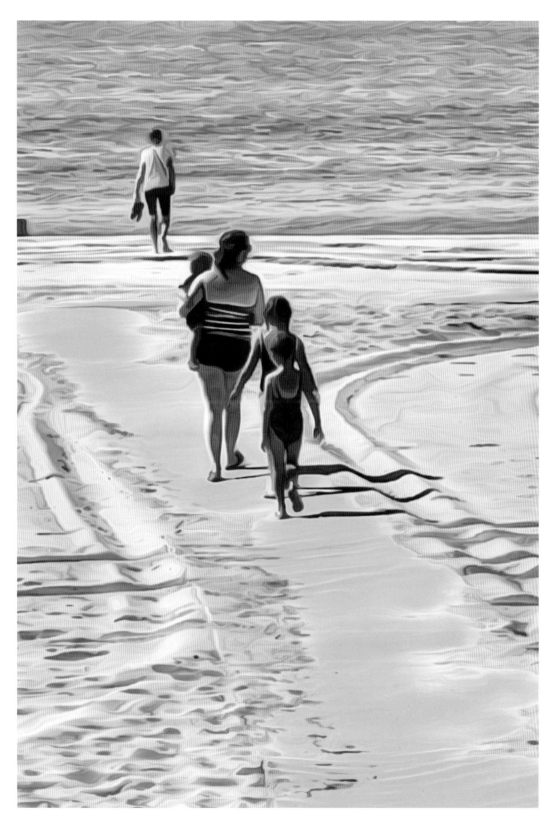

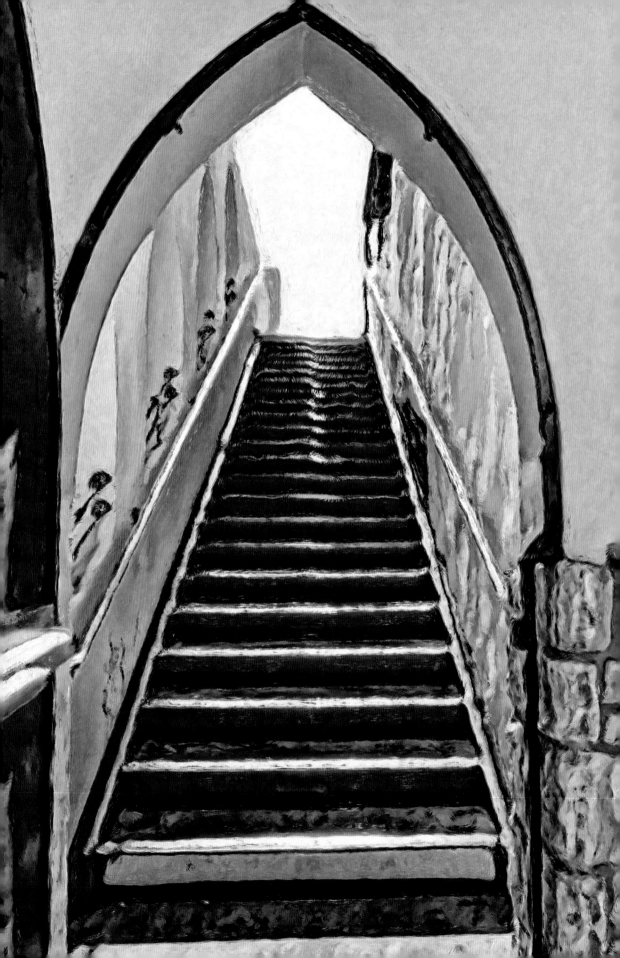

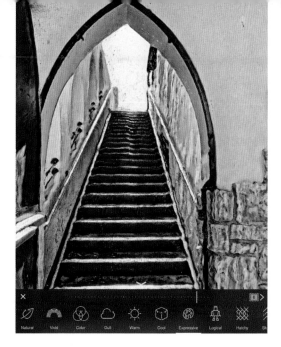

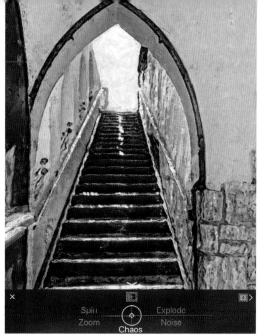

Use Compelling Compositions

As you begin to transform photos using your iPhone apps, try to create a compelling photographic composition. There are rules, such as the rule of thirds or the golden triangle, where the subject should delineate a triangle. Also, there are compositional elements such as diagonals, patterns, and shapes. And you may ask, How do I use these compositional rules and design elements to make a compelling composition? I would say, all in good time. At first, don't think about rules and graphic elements too keenly. Think about what is captivating or overwhelming.

What can one not resist feeling when looking at a particular image? The eye can be drawn irresistibly up the stairs toward the sky. Can a mundane subject captivate? We ask a lot about how do we do this or that. But it could be that all we need to do is ask ourselves, is my photo compelling? Is this a photo I want to work with further?

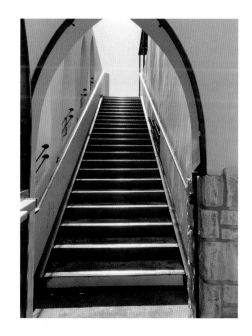

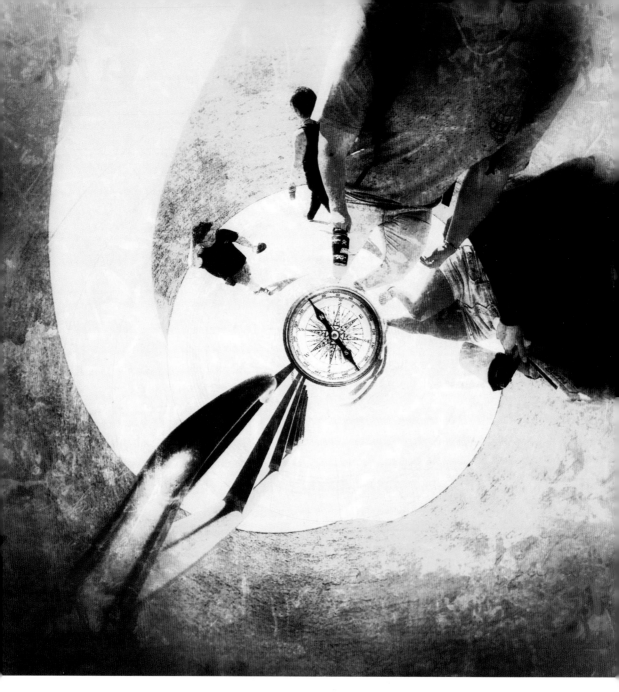

Circular Bending

This image *(above)* has some typical and atypical ways of showing perspective and depth. Distant people are smaller and on a walkway that spirals away. Closer people near the compass appear larger and overlap the more distant smaller-appearing people. Rungs on the ladder reach up from the vanishing

point where the compass is toward the immediate foreground. Overlap, size, receding lines, an artificially placed vanishing point, and a spiral each indicate depth. It is the vanishing point and spiral motion that makes the image's perspective so unusual.`

The original image *(top right)* opened in the app called Circular *(bottom left)*, circularly bends an image. Zoom, rotate, invert, and flip, among many other selections, are options for image manipulations. The option I used adds an object to the center. I used a compass. After exporting the file and importing it into Snapseed, I added a grunge filter *(below)* to create a more interesting textured feel.

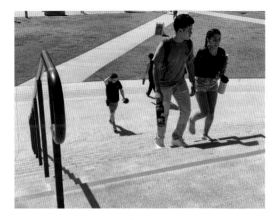

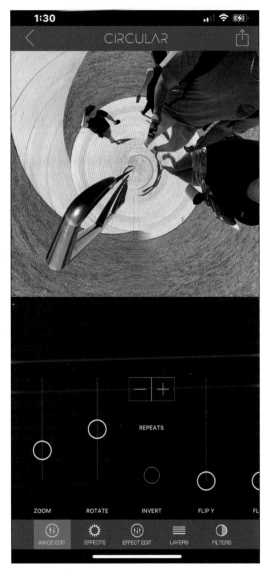

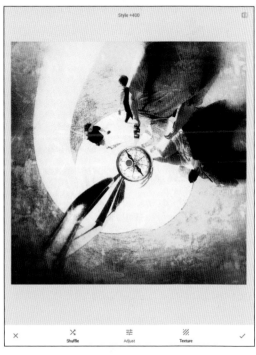

Surrealist and Cubist Image Bending

windows, bricks — swirl around the central focal point as if in a sink's

Like the previous image *(pages 112–113),* this image was processed in the app called Circular. I thought the app was a little gimmicky until I explored it and became

"This app creates images that are both Cubist and Surreal."

enchanted. Something is intriguing about how the image bends and re-shapes as if in a different dimension. Its disjunct and dreamlike reality of juxtaposed building elements makes it feel like a surrealist interpretation of an urban dwelling. Like a cubist painting, objects seem fragmented and twisted but then reassembled. A viewer will search for the proper viewpoint. The ordinarily big sky is now small but still a focal detail. The gray wall of the building is all-encompassing. Other details—birds,

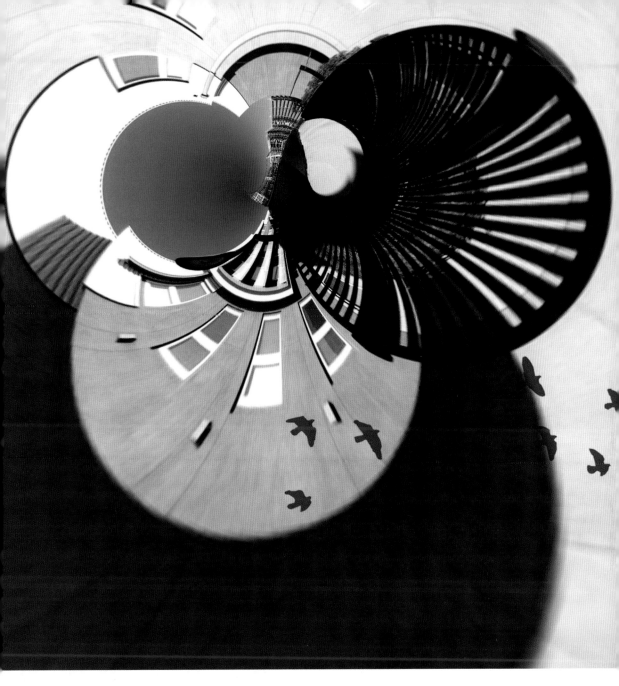

draining vortex. The app has the option of adding birds.

Surrealist art is dreamlike and seeks to unlock the unconscious mind. Cubist art abandons perspective from a single viewpoint.

This app creates images that are both Cubist and Surreal. The screenshot *(facing page)* show that there are plenty of qualities that effect the image.

Engage Viewers in the Unexpected

The unexpected is surprising and always engages viewers. Creativity, which entails the making of something new, is the basis for generating something a little different—at least novel enough to be unexpected.

"We can see that when the viewer confronts the unexpected, the whole process of viewer examination and questioning prolongs their art experience."

We've looked at many creative techniques that use apps to make different looks and styles. But these can get overused either by an individual or by the world of phone users. To keep images fresh, use striking photos from the start. There are things we can do aside from, or along with, using apps to be creative. Selecting novel angles to classic subjects is the easiest way to make a humdrum object remarkable. Try engaging an unexpected viewpoint, or do something opposite of how you naturally think of the portrayal of a subject.

In this image *(facing page),* the flower is upside down. It's a curious sight because flowers typically don't grow this way. The droplets rest on the bottom of the flower on its calyx, and the separate green sepals appear like wings. It's a successful photo because the background is out of focus, making the stem, calyx, petals, and droplets the center point. There is a tug between symmetry and asymmetry, too. But most strikingly, the flower is upside down. And we know it may be either because the camera was upside down or it was vertically inverted. On closer examination, we see how the droplets are resting on the rose, and this may be a result of the camera position. When the viewer confronts the unexpected, the whole process of viewer examination and questioning prolongs their art experience.

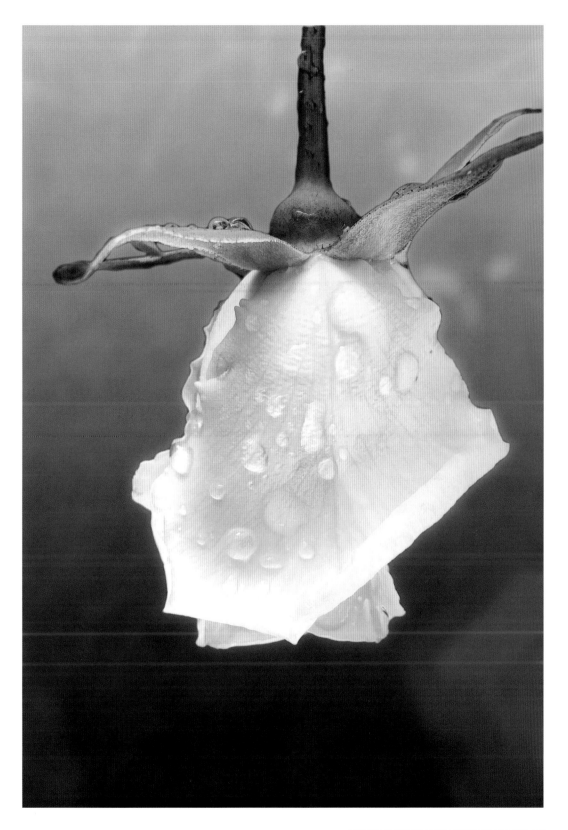

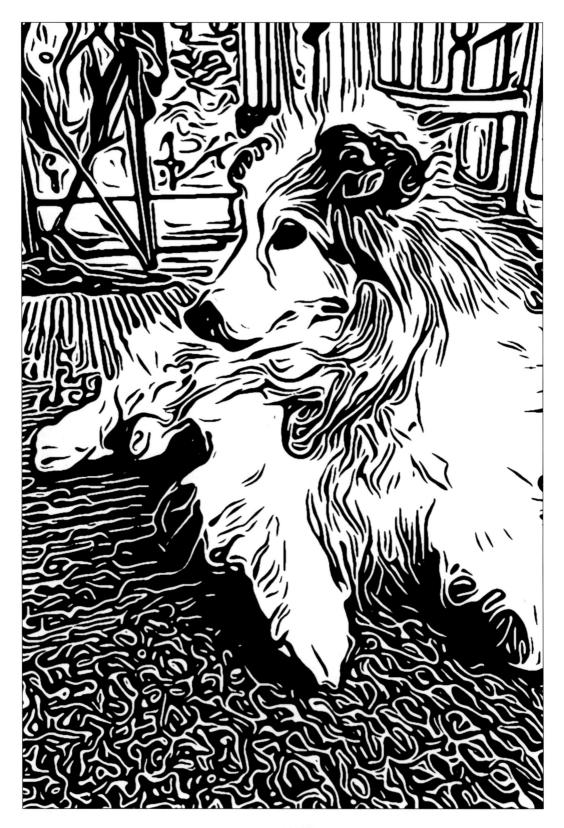

Magical Drawings

Line drawings are an art in themselves. We have a history with these drawings, probably from the beginning of time. We drew in wet sand or took a stick of burned charcoal and drew on rocks. They are done with simple tools and supplies found in most grade school classrooms and readily available to everyone online or at most general stores. Making single color drawings help you understand lines, shapes, and the basics of composition. Some may say, "You are taking a shortcut if you use an app on your phone."

I believe they are mistaken. There is much to learn using pen and paper, and it's fun. But using an app is enjoyable, instructional, and useful, too. The files created can be used for printing, just like the old fashioned drawings.

I used the app Inkworks for this image. There are many drawing styles to choose from when using this app. Besides a line drawing, this selection to me looks like an old-time block print. A wooden printing block is laboriously carved, inked with a roller, and a paper impression made. Inkworks makes the process much easier to do with a similar outcome. And like with many apps that transform your original photo, the results seem almost magical.

Texture that Moves

Think of texture as two kinds, actual and apparent. Actual textures are on surfaces that can be touched. These textures are the variations in the surface, such as a nap, grain, or weave. Although not always able to feel a surface, we can see with our eyes what the texture is. A boat surface is smooth. The water surface is rippling. Each of us has learned over time what object will have what kind of surface texture. A canoeist can tell from the texture seen on a lake if the ride will be calm or rough.

The apparent texture is a representation of actual texture. From our life experiences, we know the different looks of actual textures. These representations of real textures

become part of the photographer and artist's toolbox. The consistent and uniformly patterned texture is calm. Unevenly patterned and undulating texture show change and movement. As viewers of images, we identify these apparent textures as particular

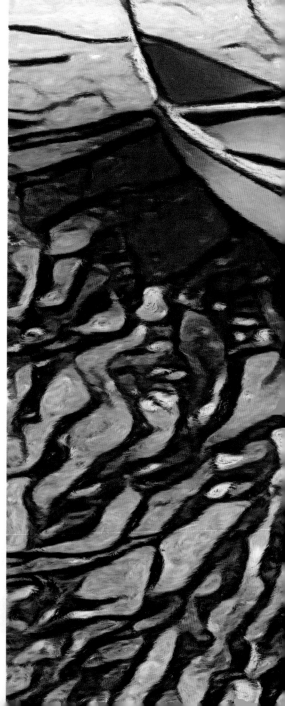

conditions of water, fur, clothing, and more.

I used the Visionist app to create a moving patterned texture to simulate water where there wasn't any in the original photo *(facing page)*. Visionist has many presets. I just had to find one that I liked, and it did the job. Amazingly this app can discern between object and background areas and assign different patterns. The patterns generated hint at a wide range of actual textures.

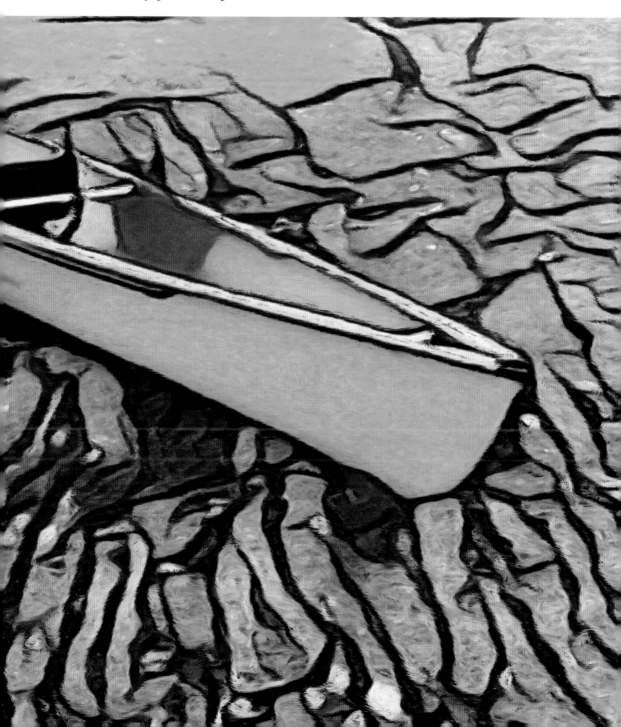

The Making of a Surreal Landscape

I used an app called Matter for this surreal image. The original photo was taken over a valley with flattened clouds, which were lower than my vantage point and the mountains across the valley. I imported the file into the app, which provides several collections of shapes. As you can see in the screenshot *(below),* there is an option to reposition the shadow. If one looks close enough, the shadow position is not consistent with the bush shadow positions. I decided against the additional objects *(facing page, bottom)* as the simplicity of the single one had more impact.

The object's surface can be changed, too. I chose a reflective surface. There is a marked contrast between the unearthly metallic object, the gauzy clouds, and the rough stony ground. I was pleased to have a subject in the original photo to place inside the reflective shape. It adds a human element.

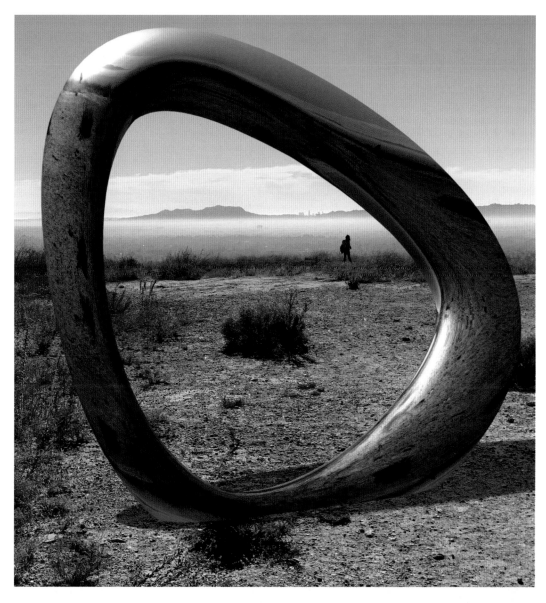

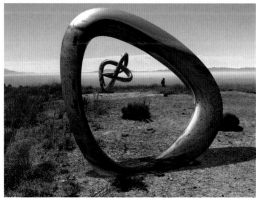

Try New Apps, Settings, and Tools

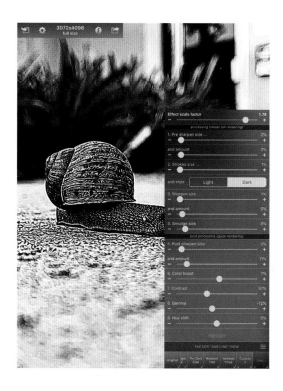

There is often a steep learning curve with an unfamiliar app. Spending time getting comfortable with an app is beneficial. It becomes second nature and instinctual. Remember to push your artistic boundaries, too. If you've been using only one app for an image, try importing it into a second or third app to see if they further refine your final art image. If you are impressed with what you've done, don't stop there. Try a new app, setting, or tool on that same

"Push your boundaries."

image. The final image *(facing page)* of the snail made using the Tangled app. I had tried several other apps *(below)*. But Tangled let me experi-

ment *(see screenshot, above)* with something different, and I like the outcome. Push your boundaries. Google the app you're using, and see what art images others have accomplished with it. When you're ready, print your art, frame it, and hang it on your wall to enjoy.

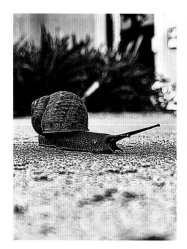

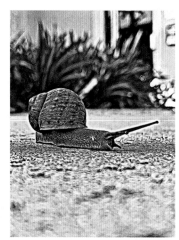

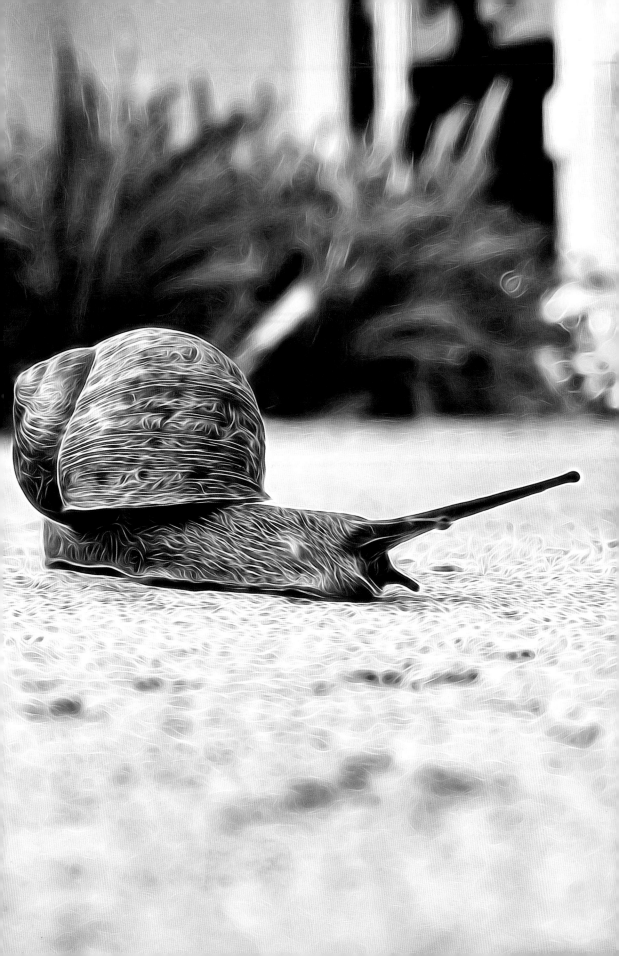

App List

This list offers general classification of apps but does not reflect their full potential. Many of the apps listed fit in more than one category. Many more apps deserve to be on the list and you may find that some get retired. New apps are always being created and existing apps are often refined and updated. Have fun discovering, exploring, and creating!

Camera Apps

Camera+2
EFEKT
Halide
Moment
Pixlr
ProCamera
Slow Shutter
VSCO

Editing and Image Refinement

Adobe Lightroom
Adobe PaintCan
Adobe PS Express
Adobe Photoshop Fix
Adobe Photoshop Mix
Curves
Darkroom
Formulas
Gloomlogue
Polarr
Snapseed
Noir
LensLight
Light Ray 2
Mextures
Rays

Handy Tools

Adobe Capture
Handy Photo
Straightener
ViewExif Image

Art Media Simulating

ArtCard
BeCasso
Brushstroke
Deep Art Effects
Glaze
iC painter
Inkworks
My Sketch
Oilist
Pic Sketch
Picas
SnapDotStipple
Waterlogue

Artistic Styles and Effects

Glitchy Psychedelic
 Camera VHS
MOLDIV
Visionist
Kansulmager
Gloomlogue
Matter
Tangled FX
Thyra
DistressedFX+
Formulas
Picas
Pixlr
Percolator
Snapseed
Visionist

Image Manipulation

aType
Circular
WordFoto
Fragment
BrainFever
Kansulmager
Matter

Layers and Filter

Adobe Photoshop Mix
DistressedFX+
Formulas
Pixlr
Snapseed

Index

AmherstMedia.com

Create Pro Quality Images with Our Phone Photography for Everybody Series